FRANCIS TOWNE

Lone Star of
Water-colour Painting

OTHER WORKS BY ADRIAN BURY

Water-colour Painting of To-day (*Studio* Special Number)

Oil Painting of To-day (*Studio* Special Number)

The Art of Reginald Eves, R.A.

John Varley of the 'Old Society'

Thomas Collier, R.I., Chevalier of the Legion of Honour

Richard Wilson, R.A., the Grand Classic

Two Centuries of British Water-colour Painting

Thomas Rowlandson's Drawings

Shadow of Eros: the Life and Work of Sir Alfred Gilbert, R.A., M.V.O., D.C.L.

Joseph Crawhall: The Man and the Artist

Syon House

Leaves of Syon

An Elizabethan Coronal

Look Back in Love

Etc., etc.

Editor of the Old Water-colour Society's Club Volume since 1945

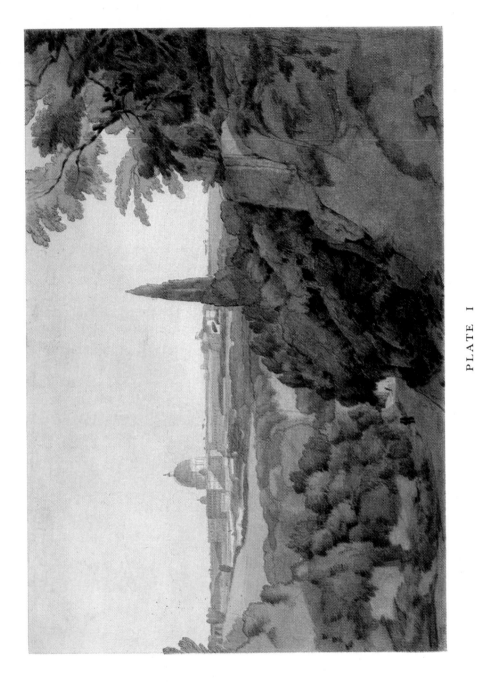

PLATE I

St Peter's at Sunset, from above the Arco Oscuro

British Museum

FRANCIS TOWNE

Lone Star of
Water-colour
Painting

By

ADRIAN BURY

R.W.S.

London: CHARLES SKILTON LTD

PUBLISHERS AND PRINTERS

Printed and made in
Great Britain and
published by

Charles Skilton Ltd
50 Alexandra Road
London SW 19

★

North America
Abner Schram Enterprises
1860 Broadway
New York
N.Y. 10023

ISBN 0284391 883

© Adrian Bury 1974

Dedicated to C. G. Greenshields, Esq., Q.C.,
Founder of the
Elizabeth T. Greenshields Memorial Foundation
Montreal,
Designed to Promote and Encourage
Sound Basic Education in the Arts

Contents

Illustrations

Introduction and Acknowledgments

It was not until the late Paul Oppé wrote about Francis Towne in the Eighth Volume of the *Walpole Society* (1919–1920) that the world became aware of the importance or even existence of this artist. Thanks to this article Towne was rescued from an obscurity lasting about a century. A few connoisseurs may have seen the occasional vagrant water-colour, or the series of Roman ones that, following Towne's wish, were presented after his death to the British Museum; but whatever was written about him in the nineteenth-century —the *Gentleman's Magazine* obituary notice of 1816, a note by Redgrave, a brief biography by Winslow Jones, reprinted (1890) from *Devonshire Notes and Gleanings*, Vol. III, p. 17,—was not of sufficient interest to attract attention and resuscitate Towne's reputation. His art would appear to have died with him. Doubtless some vague memories of his personality survived in Exeter where he lived and worked for the greater part of his life. Visitors to Barton Place, the home of the Merivale family, saw some, at least, of the many pictures and drawings that had been carefully preserved since John Herman Merivale, Towne's residuary legatee, came into their possession on the death of James White, the principal legatee. White and the Merivales were Towne's intimates in Exeter, and the artist being a widower without descendants was moved out of gratitude to pass on to them the result of an exceptional talent and some of the money that he had accumulated during a long lifetime's industry and thrift. Towne had taught members of the Merivale family to draw and he and John Merivale Senior, as well as James White, had been on sketching excursions together. To them he was not merely the professional drawing-master, but a dear friend respected and admired for his gifts and character. Such is clear about Towne's happy and successful connection with Exeter. His was not a career or temperament making for dramatic biographical revelations. Indeed, as Paul Oppé wrote, "The material for Towne's life is, as usual, very scanty". I have, however, done my best to collate all the available facts, to set them in chronological sequence, and to construct

11

some idea of the man as revealed by his friends and associates, his travels, his surprising marriage in old age to a young dancer of French extraction, and his ideals in art. The chief reason for this book, however, is that Francis Towne speaks, as it were, to a larger public for the first time through his own works. In looking at the number and variety of the reproductions we can now gain a compact and complete idea of the quality of an artist who, during the last forty years, has taken a deservedly high place in our great school of water-colour painting. Born before the middle of the eighteenth-century, Towne may be said to be conspicuously among our pioneers of this method in art. I would go farther and say that he was in some ways the most original and individual exponent of all the early English water-colourists. As regards design, tints, and the *pen style* which he generally but not invariably practised Towne seems to stand alone. His way of expression was not *materially* influenced either by his predecessors or contemporaries. Though Towne was indebted to Claude and Richard Wilson in the matter of oil painting, he evolved his own unique water-colour manner and retained it with little modification until the end of his life.

It but remains for me to thank all those ladies and gentlemen who have so courteously found time to answer my innumerable enquiries.

To Mrs C. H. Merivale I am indebted for permission to reproduce the portrait of Francis Towne by John Downman; and to her son Mr Stephen C. Merivale for the loan of books relating to his distinguished family, the portrait of John Herman Merivale, and the amusing letter dated June 26, 1806, regarding Towne printed on page 47.

I thank the Earl of Devon for giving me the facts about the oil painting, *Powderham Castle*, and the Earl Halifax for permission to see and reproduce it. I am greatly obliged to Sir William Worsley, Bt., for allowing me to study his fine collection of Francis Towne's works at Hovingham Hall, and to reproduce some of them. Lord Clifford of Chudleigh, whose ancestors employed Towne as drawing-master, kindly answered questions regarding his collection of the artist's water-colours of Ugbrooke Park. Dr R. Churchill Blackie, M.Sc., Curator of the Royal Albert Memorial Museum and Art Gallery, Exeter, has been most helpful in supplying me with information about Towne's works there. I thank Mr N. S. E. Pugsley, City Librarian, Exeter, for many suggestions and the loan of the anonymous *Essays by a Society of Gentlemen at Exeter* (1796). Mrs Kathleen M. Miller of the Devon

and Exeter Institution, and Mr Antony Gibbs sent me the biographical facts about Towne in *Devonshire Notes and Gleanings*, aforementioned. Since Towne is often said to have been born in Exeter I made the necessary enquiries there. Mr David F. Graddon confirmed that Towne's name does not appear in the Cathedral registers. He also called my attention to the considerable notice about the artist in *Le Paysage Anglais, à L'Aquarelle 1760–1851*, by Henri Lemaitre. Dr W. G. Hoskins assured me that "Towne does not appear as a local name (i.e. Devon and Cornwall) in the thousands of marriage licences for the period 1730–1800; nor does it appear among the tens of thousands of local wills for the 17th and 18th centuries." Mr Allan Brockett, M.A., consulted the Cathedral library, and offered me some useful suggestions. The Rev. Canon J. H. Adams provided me with information about the law-suit in which Towne gave evidence at Hereford in 1813, and the letter from Mrs Flowerdew to Captain Dale in which the artist is mentioned. Sir John Heathcote Amory, Bt., Miss J. M. Loveband, Mr A. W. Snow, Mr T. R. C. Blofeld and Mr J. White Abbott, descendant of Towne's pupil of the same name, were other helpful correspondents.

For permission to use information in Paul Oppé's article, and the extract regarding Towne in *Thomas Jones's Memoirs*, I offer thanks to Miss Margaret Whinney, Honorary Secretary and Editor of the Walpole Society, that Institution and *Volume* indispensable to all art scholars, connoisseurs and collectors.

Mr D. L. T. Oppé and Miss Oppé gave generous permission for me to reproduce certain Towne pictures in their great Collection. Miss Scott-Elliot afforded me similar facilities in regard to her important Towne picture *The Salmon Leap, Pont Aberglaslyn* and also kindly called my attention to the Towne references in the unpublished part of the Farington Diary. Mr Tom Girtin informed me about some works in private hands, Mr Gilbert Davis gave me particulars about his one-time Collection of the artist's water-colours, and Mr Brinsley Ford allowed me to draw on his knowledge of English artists in Rome during the eighteenth century.

To Mr Edward Croft Murray and his colleagues in the Department of Prints and Drawings, British Museum, my gratitude for their friendly, unfailing help. This applies also to the staff of the Victoria and Albert Museum Art Library, and to the custodians of the Fitzwilliam, Ashmolean, Leeds,

Sheffield, Norwich, Laing (Newcastle-upon-Tyne), Whitworth (Manchester), Edinburgh, Aberdeen, Cardiff, Bath, Plymouth, and Toledo, U.S.A., Art Galleries. As usual, I found the Witt Library (Courtauld Institute) a valuable source of research. To the Trustees of the Cecil Higgins Art Gallery, Bedford, my thanks for permission to reproduce the *Colosseum from the Caelian Hill*, and loan of the colour-plate. Mr F. Gordon Roe, F.S.A., provided me with the facts about Towne's marriage, from some notes by the late Basil S. Long in his possession.

The officials of Somerset House sent me a copy of Towne's Will, which determined approximately his monetary fortune.

For permission to consult the Ozias Humphry correspondence in the Royal Academy Library, my thanks are due to Mr Sidney C. Hutchison, F.S.A., the Librarian.

The *Connoisseur*, *The Antique Collector*, The Old Water-Colour Society's Club, *Museums Journal*, the *Western Morning News* and *Exeter Express and Echo*, are acknowledged for publishing articles and letters regarding Towne.

If I have omitted any of my correspondents, will they accept a general acknowledgment of their assistance? Finally, a word of appreciation to several personal friends who have patiently shared my interest in this book, notably Sir William Russell Flint, R.A., P.P.R.W.S., that contemporary artist whose water-colours will stand secure with those of his greatest forerunners.

<div align="right">ADRIAN BURY, R.W.S.</div>

FRANCIS TOWNE

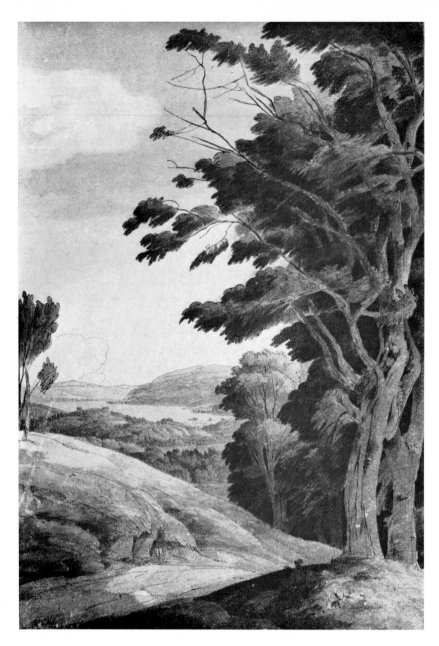

PLATE II

View from Rydal Park

City Art Gallery, Leeds

The Man and His Friends

Few artists have as obscure an origin as Francis Towne. It is not known where he was born, although Exeter is assumed to have been his birthplace. That the year was either 1739 or 1740 can only deduced from his age as given at the time of his death in 1816. Singular indeed is it that an artist who is described in the *Gentleman's Magazine* for 1816, part 2, p.94 as "of great eminence as a landscape painter", and one moreover who numbered among his friends several important artists and patrons, should be lacking in recorded parentage. The mystery has been unsolved by all who have made researches into Towne's life. No clue has come to light in contemporary correspondence, Towne's marriage and burial certificates and Will. The assumption that he was born in Exeter derives from the fact that he lived for many years on and off in that city, that his closest friends were Exeter men, and that he was interred there in Heavitree churchyard.

We have Towne's authority in a letter written to Ozias Humphry that he began to paint in oils at the age of fourteen, but whether this was at Exeter or at Shipley's School, London,[1] there is no definite knowledge. The fact that Humphry as a boy attended Shipley's, was a native of Devonshire, and associated with Towne all his life may have given credence to the idea of Towne's initial studies at Shipley's. John Downman, on his portrait of Towne, describes him as "Landscape Painter of Exeter".

Certain it is that Humphry was at Shipley's, and Towne knew him during that period. Another Devonshire boy who was at Shipley's in 1755

[1] "Shipley's School or Academy was located in Castle Court, Strand, whither the Society of Arts offices were moved in 1756. The school may have been started in the house taken by Shipley for the Society in Craig's Court in 1755, and it is possible that when the Society moved to the house opposite Beaufort Buildings Shipley's Academy may have been accommodated in part of the premises.

"After this, when Shipley's official connection with the Society had ceased, it appears to be certain that his Academy was moved to the house at the corner of Beaufort Buildings (afterwards No. 96) Strand After Shipley left London, the School was carried on for some time by Henry Pars, the brother of William Pars, A.R.A., and its pupils took many of the Society's prizes. Beaufort Buildings disappeared about 1902–4, when the new Savoy Hotel buildings were erected." (*A History of the Royal Society of Arts*, by Sir Henry Trueman Wood, with a Preface by Lord Sanderson, G.C.B., John Murray, 1913).

Towne's pupil and friend, John White Abbott, said that Towne was a pupil of John Shackleton, painter to George II. See *Farington Diary*, Vol. I, p. 211. Shackleton exhibited a portrait of George II and two others at the Free Society in 1763, and three portraits at the same Society in 1766.

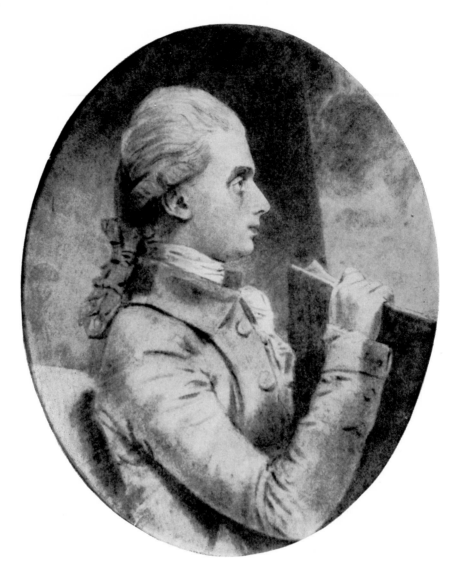

PLATE III

Francis Towne by John Downman, A.R.A.

By permission of Mrs. C. H. Merivale

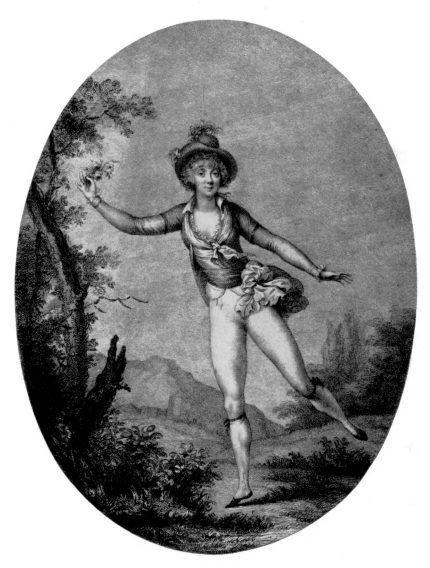

PLATE IV

Mlle Jeannette Hilligsberg

who married Francis Towne at St. Marylebone church on August 5th, 1807. A well-known dancer, she appeared at the King's Theatre, Haymarket, Drury Lane and Covent Garden. She died on April 16th, 1808, at the age of 27, and was buried in Heavitree churchyard, Exeter.

From an engraving by J. Condé after H. de Janvry

was Richard Cosway. He was something of a prodigy, for he won Society of Arts premiums in 1755, 1757, 1758, 1759 and 1760.

Towne gained a first premium of the Society of Arts in 1759.[1] Recalling this success many years afterwards, he stated that the prize was for the best drawing of a landscape, but the subject is recorded in the Society's archives as "an original design for Cabinet makers, Coachmakers, manufacturers in Metals, China and Earthenware".[2]

Towne lost no time in pursuing his career as an artist, for in 1762 he exhibited three works at the second exhibition of the Society of Artists in Spring Gardens. They were entitled *A Landskip, Its Companion, A Piece of Flowers*. He was in the best company, Reynolds showing his *Garrick between Tragedy and Comedy*, and portraits of *Lady Elizabeth Keppel* and *Countess Waldegrave*, and one of several pictures that he painted of Nelly O'Brien. Richard Wilson had six important works at the same exhibition, including *The Thames near Richmond*, and a *View of Holt Bridge on the River Dee;* while Paul Sandby was represented by five pictures.

Towne was made a member of the Society in 1772 and showed two works in that year, and two in 1773, one of which was perhaps his most ambitious effort *A Large Landscape with a View of Exeter*.

The artist exhibited at the Free Society in 1763 and 1766. He made his début at the Royal Academy in 1775, and showed works there at intervals until 1810. His first contribution to the British Institution was in 1808, his last in 1815.

The Society of Artists catalogue for 1762 gives Towne's address as At Mr. Koon's James Street, near Brook Street, Grosvenor Square. The following year the Free Society records Longacre. In 1766 the address is Opposite Beaufort Buildings, Strand, a place also used by Towne's friend William Pars [3] before the latter went to Greece in 1764. In 1769, according to the Society of Artists' catalogue, the address is "At Mr. Pars", Percy Street, Soho.

[1] There is no trace of this drawing in the Society's archives.

[2] The entry is in Dossie's *Memoirs of Agriculture*, Vol. III, 1782, p. 416, and reads 1759 *Under 22 years*. Fr. Town (sic) Landscape painter, Exeter, of 15 gs. 1st share.

[3] William Pars (1742-1782), water-colourist and oil painter of distinction, who studied at Shipley's School. In 1764 he was chosen by the Society of Dilettanti to accompany Dr Richard Chandler and Nicholas Revett to Greece where he made many drawings. He was elected an A.R.A. in 1770, and in 1775 was sent to Rome, also by the Society of Dilettanti, for further study. He died there in 1782 as a result of catching cold by standing in the water at Tivoli to make a sketch.

The fact that Cosway also used Opposite Beaufort Buildings links these three young artists together at the beginning of their careers. [1]

These addresses do not mean that Towne lived permanently at any of them, though on his early occasional visits to London he may have stayed with Pars. They were accommodation addresses to which he sent his pictures and whence they were forwarded to the various exhibitions. A letter from Pars undated speaks of a "a rough home which is always at your service". As far as can be ascertained from the titles nearly all these pictures were landscapes, but *A Large Landscape with a Scene in Shakespeare's Cymbeline* is recorded as having been exhibited at the Free Society in 1763.

My opinion is that Towne went back to Devonshire after completing his studies in London. Looking at his work as a whole it is obvious that he was something of a solitary. He loved open spaces, natural scenery and ruins. His ambitions were mainly aesthetic, though, as we shall see later, he was far from indifferent to money. He was never an active participant in the politics of art and avoided the conflicts and jealousies inseparable from the pursuit of ambition and the achievement of fame. The artist took no side in the troubles that occurred when certain members of the Society of Artists seceded to form the Royal Academy in December, 1768.

When Towne first exhibited at the Royal Academy in 1775, his address was given as "At Mr. Pars, Percy Street". He did not show in London again until 1779 when, sending his pictures from Exeter, he entrusted them to the care of Ozias Humphry, and was congratulated by Cosway on at length deciding to emerge from his retirement. [2]

Cosway's comment and the year are significant for they indicate that Towne had been detached from London for a long time, and probably had been working in Devonshire for about twenty years. Here with Exeter as his headquarters the artist was content with a local reputation as a painter, draughtsman of country seats and as a drawing master. His success was emphasized by his large landscape, *Exeter from Exwick*, exhibited at the Society of Artists in 1773, and which is now in the Royal Albert Memorial Museum, Exeter.

[1] John White Abbott, Towne's most gifted pupil, according to the Farington Diary, Vol. 1, p. 211n., stated that Towne "joined with Cosway in taking a house in Somerset-street, Portman-square, where they embarked in the world as artists"; but G. C. Williamson in his *Life of Cosway* gives Cosway's address as Orchard Street, Portman Square, and makes no reference to Towne.

[2] A. P. Oppé, *Francis Towne, Landscape Painter*, Walpole Society, Vol. 8. 1919–1920.

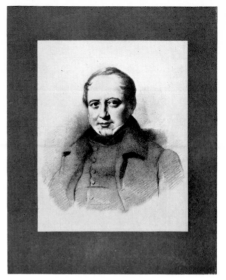

John White Abbott (1763–1851)
Oil painting (6¼ x 5 in.)
BY JAMES LEAKEY

White Abbott was Towne's most gifted pupil. By profession a medical man, he devoted much time to art. He assimilated Towne's drawing and water-colour style, though he could paint on a considerable scale in oils, exhibiting as an amateur at the Royal Academy

Royal Albert Memorial Museum, Exeter

John Herman Merivale
(1779–1844)

who inherited Towne's estate, including the drawings and paintings after James White's death in 1825. Lawyer, poet and translator of poetry, he was congratulated by Byron on his translation of the *Morgante Maggiore* of Luigi Pulci

From an engraving by J. Posselwhite, after an original drawing by E. U. Eddis

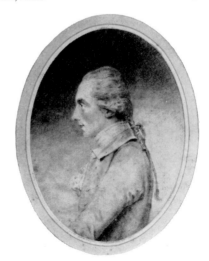

James White
BY JOHN DOWNMAN, A.R.A.

A great friend of Towne, White was a bencher of Lincoln's Inn and practised law in Exeter. He was an enthusiastic *amateur d'art*, and introduced Towne to the Merivale family about the year 1781. He was the artist's executor and residuary legatee for life. James White died at his house in Garden Square, Exeter, on June 28th, 1825, aged 80, when, in accordance with Towne's Will, John Herman Merivale inherited about £3,000 and all the artist's unsold pictures and drawings with the exception of a painting called *Falls of the Terni*

Royal Albert Memorial Museum, Exeter

PLATE V

Since so little direct knowledge as to his life is available we can but try to visualise it by reviewing the personalities and activities of certain Exeter friends, among whom Towne was engaged professionally and socially. They were principally the Merivale family, James White and his nephew John White Abbott, William Jackson and Francis Downman.

John Merivale (1752–1831) was "a sturdy, conscientious dissenter of the old school combining with his dissent an absolute horror of radicalism and disloyalty, as some of the old church and state dissenters did in those days. When Mr. Timothy Kenrick, the Unitarian minister at Exeter, preached a sermon after the death of Louis XVI favourable to Jacobinism Mr. Merivale indignantly withdrew for a time his connection with the meeting, and held a family conventicle in his house". [1]

According to Dean Merivale's *Autobiography* (1899), John Merivale was the only child of Samuel Merivale, "who came out of Northamptonshire (Middleton Cheney) and had settled in Devon early in life as a Presbyterian minister, where he married a Miss Shellaber. Removing to Exeter he was theological tutor at a Dissenting Academy there".

John Merivale, inheriting money and property from his father, did not engage in any business or profession. He married in 1773 Ann Katenkamp, daughter of an Exeter merchant of German origin, lived round about Exeter until 1781, in which year he took a house in the Close, or "Churchyard" as it was called, remaining there till 1797. Desiring a residence in the country, Merivale bought an estate of about 140 acres called Barton Place, two miles to the north of Exeter on the road to Crediton. In an elevated position commanding a lovely view of the valleys of the Exe and Creedy he built a commodious house. It is still there with views not greatly impeded by development since. The house is now part of the University of Exeter.

In the summer of 1797 John Merivale with his wife and two daughters, Nancy and Fanny, entered into possession of Barton Place. His love of nature and art, his generous and kindly attitude, especially to the poor, were characteristic of his temperament. Merivale enjoyed riding over the countryside by himself, and he would wander about his estate, the grounds of which he laid out in woodlands and gardens. He liked playing the flute, and one might have seen him "sitting pensively on a seat or leaning over a

[1] *Family Memorials* compiled by Anna W. Merivale, (1884).

23

brook with the instrument to his mouth His tall figure, large bushy eyebrows and rough complexion were not set off by any advantage of dress. His habiliments were slovenly and his general appearance uncouth; but he was a thorough gentleman in feeling and demeanour". [1]

Although John Merivale was about ten years younger than Francis Towne, the two men must have had much in common, and a friendship that began about 1780 lasted till the end of Towne's life in 1816.

We can imagine that the artist was always made at home by the Merivale family. He instructed the children, Nancy, Fanny and John Herman in the rudiments of art. It was John Herman Merivale (1779–1844) who inherited Towne's estate, including the drawings and paintings, after James White's death in 1825. Like his father, John Herman was brought up in strict Presbyterian principles. A man of many gifts, he was educated at Harrow and St John's College, Cambridge, was called to the bar in 1804 and became a Commissioner in Bankruptcy in 1831. His tastes, however, were literary, and he was a good poet and translator of Italian and German poetry. He had known Byron at Harrow, and the author of *Don Juan* congratulated him on his translation of the *Morgante Maggiore* of Luigi Pulci. In 1803 John Herman Merivale married Louisa Heath Drury, whose father had been appointed Headmaster of Harrow in 1785.

Of an earlier generation among Towne's friends was William Jackson (1730–1803) the musican. He composed the music for the *Lycidas* of Milton which was performed at Bath and conducted the opera at Gyde's rooms in 1767. As W. T. Whitley writes in his *Gainsborough*, "It was an occasion upon which Gainsborough was sure to be present, for the performers included his friend Giardini, the violinist, whom he had known at Ipswich. Gainsborough adored music and Jackson was an amateur painter. When a young man Jackson made the acquaintance of Collins, [2] who came to Exeter when the musician was endeavouring with small success to add drawing to his other accomplishments".

Jackson taught music at Exeter until 1777 when he was appointed sub-chanter, organist, lay vicar, and master of choristers to the cathedral. As a composer his greatest success was his opera *The Lord of the Manor*, produced

[1] *Family Memorials*, by Anna W. Merivale.

[2] Samuel Collins, who practised miniature painting at Bath, and in Dublin. Ozias Humphry studied with him originally.

at Drury Lane in 1780. He was an honorary exhibitor at the Royal Academy. If, as has been said, Gainsborough had little sympathy with Jackson's attempts to be an artist, Jackson was more than critical of Gainsborough's efforts to be a musician. In one of his books of essays,[1] he writes,

"When I first knew him [Gainsborough] he lived at Bath, where Giardini had been exhibiting his *then* unrivalled powers on the violin. His excellent performance made Gainsborough enamoured of that instrument; and conceiving, like the servant-maid in the *Spectator*, that the music lay in the fiddle he was frantic until he possessed the very instrument which had given him so much pleasure but seemed much surprised that the music of it remained behind with Giardini!"

James White, whom Downman inscribes on his portrait sketch of him as "that excellent man", was a Bencher of Lincoln's Inn, who lived and practised in Exeter. According to Anna Merivale's *Family Memorials*, "his house was in a retired corner behind North Street, and he laid out some pretty grounds and plantations with ponds, arbours, etc., in the taste of the day at Fordland, in the parish of the Ide, near Exeter. In correspondence with my grandfather frequent reference occurs to the assistance he received from Mr. Merivale in his landscape gardening". James White was in regular correspondence with Ozias Humphry in London, and it is clear from his letters that he was much interested in art. White was Towne's sole executor.

Of Towne's friends in London Ozias Humphry was perhaps the most intimate. He was Devonshire born—at Honiton in 1742—and after studying at Shipley's School worked for a short time in Exeter, afterwards at Bath and in Dublin before returning to London in 1764. He travelled to Italy with Romney and spent four years there, returning to London in 1777. From 1785 till 1788 Humphry was in India. Very successful as a miniature and crayon artist, he was made a member of the Royal Academy in 1791, dying in London in 1810. So close was his friendship with Towne that the latter was one of the three persons whom Humphry mentioned on his deathbed, the others being James White and Benjamin West.

[1] *The Four Ages Together with Essays on Various Subjects*. By William Jackson (1798). Another book is *Thirty Letters on Various Subjects* (1795), and a third published anonymously, in which Jackson probably wrote most of it, was entitled *Essays by a Society at Exeter* (1796). They reveal a learned and witty mind.

John White Abbott (1763–1851), nephew of James White, was born in Exeter and practised there as an apothecary. He was a devoted amateur artist and studied with Towne whose style he assimilated. He also made copies of old masters and Gainsborough's works. His uncle took him to London and introduced him to Sir Joshua Reynolds, Benjamin West and other artists. From 1793 to 1822 he exhibited in the Honorary section of the Royal Academy, but he never relinquished the medical profession. Judging, however by the number of paintings and drawings that he achieved he must have given much time to art. A large oil, *Limekiln at Topsham*, and a small one *High Street, Exeter*, 1797, at the Royal Albert Memorial Museum, Exeter, show him to have been an accomplished artist in a style other than Towne's.

Another artist of that circle, both in Exeter and London, was John Downman (1750–1824). Although born near Wrexham he had distinguished Devonshire connections; and in 1778, as a rising portrait painter, went to the west country and lived in Exeter for a year. It was a busy and romantic one for Downman, for he courted and married as his second wife the daughter of William Jackson. Downman did many portraits of the local gentry, their ladies and Exeter celebrities. It is likely that the first of two portraits that he painted of Towne, showing the artist at about the relevant age, was done on this occasion. Certainly a friendship developed between them, thanks to mutual interests and patrons, which continued in London, for Towne used Downman's address, 5 Leicester Fields, in sending to the Royal Academy of 1789. Both artists were in the habit of travelling to and from the Devonshire city. Downman is recorded as having been in Exeter in 1796 and 1806. He used to stay with a distant relative Dr Hugh Downman and his wife, who was first cousin to Lord Courtenay. Towne had painted a picture of Powderham Castle, Lord Courtenay's residence, in 1774. Downman did drawings of John and Ann Merivale, as well as of a Mr and Mrs Louis. According to Towne's Will three members of the Louis family were beneficiaries.

Such were Towne's more important friends and he kept them all his life.

Let us return to the year 1777.

At the age of 37 Towne had established himself as a reputable artist, living in Exeter, sharing in the social life there, travelling about the county, doing drawings and paintings of country houses and landscapes. J. White

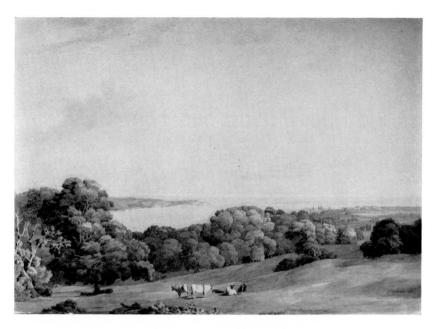

From the Belvedere, Powderham Castle

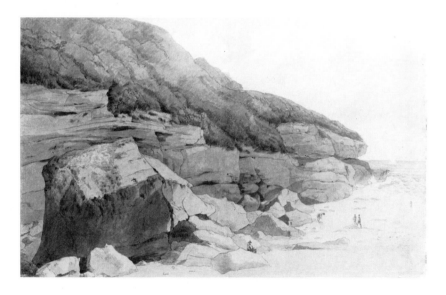

PLATE VI

Exmouth

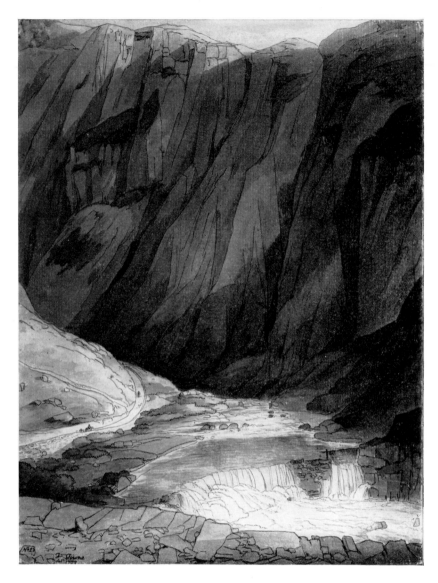

PLATE VII

The Salmon Leap, from Pont Aberglaslyn, 1777

Coll. Miss A. H. Scott-Elliot

Abbott said that he "made £500 a year by Teaching drawing", and could therefore live in a comfortable style if he wished. Towne was extremely economical and guarded against the financial worries commonly associated with a precarious profession.

As to his Devonshire patrons they were numerous, important and influential. Towne visited the sixth Lord Clifford of Chudleigh at his great new house built by Robert Adam about 1760, and taught his children. Many are the water-colours that the artist did in Ugbrooke Park, and the present Lord Clifford has ten such works in his collection. The peace and beauty of this splendid domain must have been very inspiring to Towne. The even older ancestral estate, Powderham Castle, part of it dating from the time of Richard II, was well known to the artist, and he enjoyed sketching from the then recently erected Belvedere Tower, commanding magnificent views over the estuary of the Exe and the county generally.

There were Sir Stafford Northcote at Pynes House[1], in the neighbourhood of Cowley Bridge near the junction of the Exe and Creedy, and Sir Thomas and Lady Acland at Holincote. Thomas Taylor of Denbury, and Michael Sanders of Oatlands encouraged Towne by commissioning paintings and may have employed him as tutor. He knew the Champernownes of Dartington Hall, and did many drawings of Peamore Park.[2]

Perhaps by 1777 he had temporarily exhausted Devonshire subjects, prolific as they are, and thought a change of scene might be beneficial to his art, so he made a tour of Wales, it is said, with James White. Towne had evolved a style in the tinted drawing far more personal than his oil technique. The Welsh mountains were to inspire him further to develop this manner, for *The Salmon Leap from Pont Aberglaslyn*, which dates from 1777, is conspicuously original in its austere and dignified vision of nature. It is the harbinger of the great style with mountain drawings that he was to perfect in Switzerland.

The beauty of Wales played an important part in the rise of our landscape school, but Towne's delicate pen line and precise patterning were entirely different from the more realistic manner that came with Paul Sandby, and

[1] Now the home of the Earl and Countess of Iddesleigh.

[2] Peamore House and Park, of which Towne did many drawings, lie a mile and a quarter due south of Alphington church, Exeter. For an indefinite but long time it was in possession of the Northleighs. About 1790 the property was owned by Henry Hippesley Coxe. Between 1800 and 1810 Peamore was in possession of the Kekewich family, who owned it till 1945. It is now a residential hotel.

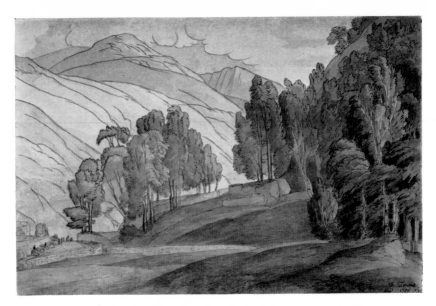

Vale of St. John in Cumberland, looking towards Grasmere

Private collection *Photograph by courtesy of the Fine Art Society*

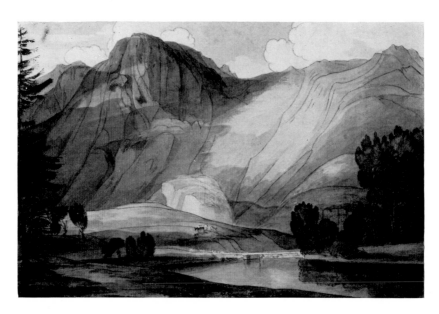

PLATE VIII

Raven Crag with Part of Thirlmere

Fitzwilliam Museum, Cambridge

was to come later with Girtin, Cotman and John Varley. Nor as a draughtsman had Towne anything in common with Richard Wilson's romantic manner. He had "carved out," as it were, a method of his own, and I will discuss this in the critical chapter.

The Welsh tour was a rehearsal for the Grand Tour. Having changed the routine of his life by a trip to 'Wild Wales', Towne's thoughts were directed towards Italy. Most artists of his time regarded a visit to Rome and Florence as essential to their education, and maybe Towne's patrons were sympathetic to this project, though there is no record of any financial help or specific commissions. Richard Wilson, who had done landscapes in Wales before going to Italy, Reynolds and other painters and sculptors of genius had preceded Towne by about twenty years, and Humphry and Downman had also been to Italy and but lately returned. Pars, after his visit to Greece on behalf of the Dilettanti Society, was sent to Rome by the same Society in 1775.

Towne is certain to have seen many paintings and drawings made in Italy and Switzerland by his contemporaries, possibly the works of John Robert Cozens after his return to England in 1779 about the time that Towne set forth.

There is no proof that Towne travelled to Italy with John "Warwick" Smith as is stated in the Farington Diary, but he certainly met Smith in Italy. They sketched together there, and in Switzerland and travelled back to England in company in the autumn of 1781. This encounter with Smith was to have some slight influence on Towne's work.

The artist's itinerary may be followed from the dated drawings done on his journey out and back. He would appear to have gone direct to Geneva, for the first recorded drawings were made there on September 7, 1780.

By October Towne is in Rome, and I do not doubt that his immediate objective was the Colosseum. This monstrous relic of antiquity has ever been irresistibly fascinating to visitors, especially artists. Some of Towne's finest drawings were inspired by the Colosseum, and the earliest one in the Roman series is dated Oct. 16. Clearly Rome is his headquarters for the time being, and by the end of November, 1780, he had achieved several elaborately constructed versions of the great amphitheatre. Towne was learning a difficult subject, and by the concentration so obvious in these drawings he began to master the complex difficulties of architectural facts

and the problem of scale. A drawing dated December 12th 1780 proves that the city and its wonderful ruins are still holding him in thrall; and the weather, as it sometimes is in Rome during December, was warm and sunny enough for Towne to work out of doors. He is making drawings of the Baths of Caracalla in January, 1781.

The numbers, titles and dates of the Roman drawings are all the evidence we have of Towne's life in the city. We do not know where he lived, how he spent his leisure and what friends, old or new, he encountered with the exception of John Smith and Thomas Jones. Probably Towne held himself aloof from the English colony of artists, and did not enter much into their social life. The amount of work that he did during the few months that he was in Italy is proof enough that he allowed himself little leisure.

Rome during the second half of the eighteenth century was a gay and exciting place. In his *Memoirs* [1] Thomas Jones gives many animated glimpses of fêtes and entertainments arranged by cosmopolitan artists and Italian and other potentates. A typical occasion was the Arcadian Entertainment organised by Gobbo Lebruzzi, historical painter, attended by grand tourists and artists. "We were regaled", Jones writes, "with Music and the Recitations of Improvisatori Poets, and refreshed with Sweetmeats, Ices, lemonades"

Prince Borghesi's fêtes in his lovely gardens attracted crowds who disported themselves on roundabouts, swings and other fun-fair contrivances. Concerts and masquerades were the order of the day and night. Foreign artists and students would give parties with national characteristics, such as a Christmas eve entertainment in the Danish style. A certain Mr D'Argent, a young sculptor from Copenhagen, invited Danes, Russians, Poles, Germans to enjoy a bill of fare consisting of a "large bowl of rice milk and fricaseed Kid, a roast Goose and Pancakes, with the best Wine that Rome could furnish".

With artists and grand tourists continually coming and going, opportunities for festive occasions were of regular occurrence. The arrival of some prince, duke or other exalted personage was the signal for public merrymaking and rejoicing.

A meeting-place for artists in Rome was the English Coffee House in the Piazza di Spagna. It was a kind of club, and Thomas Jones was not

[1] *Memoirs of Thomas Jones, Penkerrig, Radnorshire.* The Walpole Society, Vol. 32, 1946–1948.

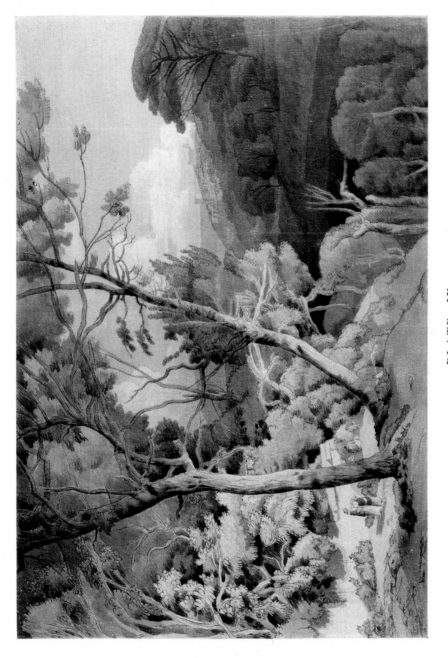

PLATE IX

Near Naples: View on the Side of a Valley

British Museum

enamoured of it. Indeed, he describes it as "a filthy vaulted room, the walls of which were painted with Sphinxes, Obelisks and Pyramids, from the capricious designs of *Piranesi*, and fitter to adorn the inside of an Egyptian-Sepulchre, than a room of social conversation—Here—seated round a brazier of hot embers placed in the Center, we endeavoured to amuse ourselves for an hour or two over a Cup of Coffee or glass of Punch and then grope our way home, darkling, in Solitude and Silence" [1]

Inhospitable as it sounds, many English artists, including Reynolds and Richard Wilson, met and even lived there. As Jones had just arrived in Rome on a wet and gloomy November day after a wretched journey from Viterbo with verminous inns *en route* his introduction to the English Coffee House was not propitious, but he was glad to meet some old friends there, among whom were Pars, Humphry and Cozens.

There was at that time a vast and not too healthy a trade in old pictures, statues, and antiques generally, most of which went through the hands of Thomas Jenkins and James Buyers who enriched themselves thereby. [2]

As a contrast to the merry-making and money-making, the occasional sad event reminded the visitors of the transience of human life against the background of the eternal city. Quite a few of the alien artists who found Rome so alluring and profitable for their study were never to see their native lands again. Jonathan Skelton, an early English water-colourist, whose mysterious career has been somewhat clarified by Mr S. Rowland Pierce's researches,[3] had died in Rome in January, 1759. Skelton was buried in the graveyard reserved for Protestants, near the Cestius Pyramid, as was Mrs Pars who died on June 6th, 1778. Her funeral by the light of the moon was a weird occasion. It was the custom for the English artists to walk in procession with torches, and for one of them to read the burial service. "The Scene was grand & striking—the Moon, just hid behind the Tomb of Caio Sesto, cast her Silvery Tints on all the Objects around, save where

[1] *Op. cit.*, p. 54.

[2] Thomas Jenkins, artist, but who could better be described as business man. He lived for years in Rome and made a large fortune by buying and selling at his "Own Prices, Old Pictures, Antique Gems & Statues with the Profits of a lucrative banking house—he was enabled to vie with the Roman Nobility in Splendor & magnificance—"

James Buyers, a professed architect, also a dealer in such wares, and adviser to the grand tourists, as well as guide to the "Various Buildings both Modern & ancient, Statues & pictures & other Curiosities in this City & its Environs"

Memoirs of Thomas Jones; Walpole Society, Vol. 32, 1946–1948.

[3] Walpole Society Volume, 1960.

the large dark Piramid threw its broad Shadow over the Place in which the Solemn Ceremony was performing by the dusky Light of the Torches —"[1]

Most of the English artists in Rome appear to have found time for relaxation from their work, but I have not discovered Towne's name among them. As I have already suggested he was too busy with his drawings, or perhaps too ascetic of temperament, or too reticent about spending money to take part in such meetings. It is strange, however that Jones, who was constantly with Pars, mentions no meeting in Rome between Pars and Towne who were old friends from the days of Shipley's Academy. But we do learn from Jones of certain adventures that he and Towne shared in the neighbourhood of Naples. Under date of March 8th, 1781, he writes:

"Towne the Landscape painter arrived from Rome, bringing me Letters from my friends at that place—I was glad to see him, as any person, particularly in my situation, must be, to see an old Acquaintance, and as his stay in Naples was not proposed to be long, I gladly offered my Services to be his *Cicerone*, and revisit with him all the Curiosities of Art and Nature in, and about this delightful City—a Circumstance rather favourable to Mr Towne, in his Profession, as I was able to conduct him to many picturesque Scenes of my Own discovery, entirely out of the common road of occasional Visiters, either Cavaliers or Artists, from Rome—In one of our Excursions, we met with an Adventure, which as it seemed likely to have proved fatal to one if not both of us, I can not help relating—

"It was Tuesday Ye 20th of March We were on the Coast of Baja making Sketches of the Two Antique Temples there, and going into a little Wine house to refresh, took out of our pockets our cold fowl and ordered a flask of Wine—This house or rather Hovel served as a place of Rendezvous for the idle Soldiers of the adjoining Garrison (The Castle at Baja has always a considerable Garrison it was built either to prevent, or in consequence of the incursions of the famous Pirate Barbarossa)—to drink and gamble at— As we were just beginning our little repast, Two gigantic Troopers entered and sat down for some time without saying a word, but casting a scowling Eye alternately on us, and at one another—at length calling for a flask of wine, which was brought them, they began to rave at the Landlady for not

[1] James Northcote, R.A., was present at this funeral, and writes p. 159, *Memorials of an Eighteenth Century Painter*, "I attended one funeral in Rome—that of an Englishwoman, the wife of Parr [sic] an English painter who died there. The company, all English, who attended this ceremony, went in hired coaches, about eleven o'clock at night, as private and quick as possible, to avoid the impertinence of the common people"

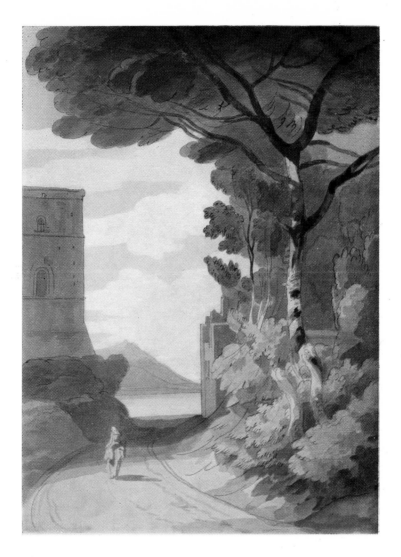

PLATE X

Near Naples

City of Birmingham Art Gallery

bringing 'Gentlemen Soldiers a drinking-glass—as well as those foreigners', pointing to us—The old Woman told them that she had but that one in the house—Upon which the leading man of the two seized our tumbler and put it on their side of the Table—I was imprudent enough to take the glass, and without ceremony put it back again—Upon which the Savage got up, and seizing me by the Throat with one hand, thrust me up against the Wall, and with the Other, drawing his broad Sword, and holding the point of it at my gullet—'Scoundrel', says he, Dost thou know what is it to affront a Soldier? (*Birbone, che sei, sai tu che cosa sia d'affrontare un Signore Soldato?*) — Towne was almost frightened to death—The old woman screamed and beg'd of them for the holy Virgin's sake not to kill the poor foreigners — that we had been often at her house and had behaved always very honorably both to her and the Gentleman Soldiers—for my part, I could neither speak or move, being almost throttled by the fellow's gripe, which is the only reason I can give for my insensibility at the moment, to the imminent Danger I was in, the bare remembrance of which afterwards made me Shudder—The tumbler glass however was immediately given up, and the fellow letting go his hold, and muttering a few execrations, returned his Sword to the Scabbard again—

"Not much relishing such Company we paid for our Wine and collecting our fragments as well as our dissipated Spirits would permit us, quitted the house, and returned, not without apprehensions of being pursued, with all the speed in our power to *Puzzuoli*—where we thought we could finish our Meal in safety. Upon Reflexion—the behaviour of the Troopers must be attributed to their disappointment in not meeting with the same regalement we had bestowed on three *Albanese* Soldiers of the same Garrison a few Days before—In excursions of this sort, the longest was of which was to Pompaeij, we were engaged till April 13, when Towne set off by the Courier for Rome—"

Jones recalls on June 2 another incident with Towne on the occasion of the latter's visit to Naples. Discussing the wild romantic neighbourhood, he writes,

"Here may visibly be traced the Scenery that Salvator Rosa formed himself upon—only taking away the Pinetrees, which were, perhaps, planted since his time, and which indicate a State of Cultivation not suited to his gloomy mind, with the addition of Water & a few Banditti —And every

39

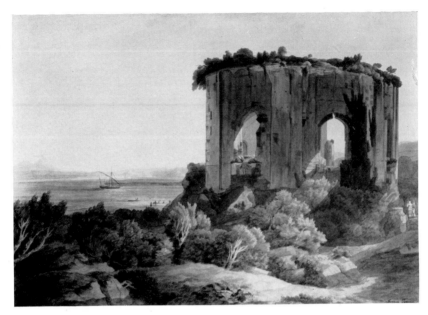

Temple of Venus, Bay of Naples. Dated 1786

Private collection

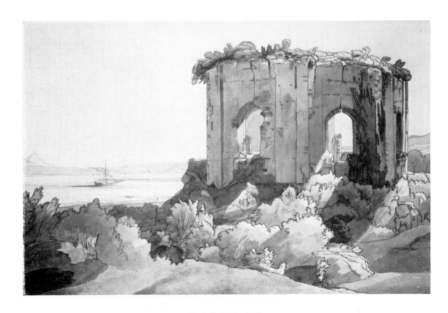

PLATE XI

Temple of Venus, Bay of Naples. Unsigned, but probably the
first sketch done on the spot in 1781 from which the above
was made

City Art Galleries, Sheffield

hundred yards presents you with a new and perfect Composition of that Master—when *Towne* was in Naples I took him with me to see this romantick place, with which he seemed much delighted—but the following whimsical Incident put a stop to further explorations at that time and which I forgot to mention in its proper place—Proceeding up the valley whose boundaries contracted more and more as we advanced, increasing in proportion the Gloominess of the Scene; We arrived at a Spot, which might very properly have been termed *the Land of Darkness & the Shadow of Death* —This sequestered place was environed on all Sides, with hanging Rocks here and there protruding themselves from behind dark masses of a variety of wild Shrubs, and overshadowed by branching Trees—Here, says I, Mr Towne, is Salvator Rosa in perfection we only want *Banditti* to compleat the Picture—I had scarcely uttered the words, when turning round a Projection of the Rocks, we all at once pop'd upon three ugly-looking fellows dressed in fantastic garb of the *Sbirri di Campagna*, with long knives, cutting up a dead jackAss.

"To have some tollerable Idea of the exteriour Appearance of this Class of men which, except in the Article of Military accoutrements, is not very different from the Neapolitan Lazzaroni—You must imagine a figure dressed as follows—*Imprimis*—an immense large three cock'd hat, trim'd with a broad scollop'd Silver or gold Lace—a Silk net, black, green or party colored, tied behind the Ears and hanging in a bag on the Shoulders, from whence three or four Tassels dangle on the back—Gold, Silver or brass Ear rings—A short crooked pipe stuck in the Mouth—a large Silk handkerchief tyed loosely round the Neck—A Short Jacket, perhaps of Velvet, with slashed Sleeves, —under that A Short waistcoat without flaps, with two or three rows of small round Silver buttons slung upon Laces, as thick as they can possibly tie & hanging in festoons—with a Silk Sash twisted round the Waist in which are stuck the pistols and dagger—A pair of large blue, red, or black shag or velvet Breeches and blue or red stockens, gartered beneath the knees with bows, or rolled up as was formerly the Custom in England—Lastly a pair of longquartered Shoes, with enormous Buckles of Solid Silver stuck over the Toes—To these add a Musket or Carbine and you have a general Idea of the Character—The Police in England and Italy, being so very different, We have no office analogous, and consequently no Correspondent term—but they Act in the different Capacities

41

Temple of Vesta, June 27, 1781 PLATE XII A Wooden Temporary Bridge over a Hollow
British Museum in the Foreground
 British Museum

of Constables, catchpolls and Thieftakers—Being likewise a kind of Military Character they serve to patrol the Streets and Highways and protect passengers and travellers from Pickpockets and Robbers —but to proceed—

"*Towne* started back as if struck by a electric Shock, strongly impressed, I suppose, with our late adventure on the coast of *Baja* —'I'll go no farther,' says he, with a most solemn face, adding with a forced smile, that however he might admire such Scenes in a Picture —he did not relish them in Nature,—So we wheeled about and returned to the more cultivated environs of the City—"

Towne, after these hair-raising adventures, was perhaps glad to return to Rome, and during the month of April, 1781 is making a tour of the city's environs, visiting Nemi, Albano, Hadrian's Villa, Tivoli, and the Falls at Terni. Many are the drawings that the artist did of these truly inspiring places. By June 27th he is back in Rome, for that exquisite drawing, *The Temple of Vesta*, is thus dated; and with occasional visits to L'Ariccia and other places during July his Italian journey is coming to an end. In August Towne is on the way north to Switzerland, visiting Florence *en route* and staying a short while in the neighbourhood of the Italian Lakes, thence to the Splügen, Glaris and Uri, reaching Geneva and Chamonix within the month. A view of Lugano dated August 24th, 1781, is, as it were, a valediction to the Italian tour. During September Towne concentrated on those sublime Alpine scenes, among which the *Source of the Arveyron* is a landmark in the British School of water-colour painting. Wrought with intense if controlled feeling for the remote majesty of nature these works are a consummation of his art, and place him among the foremost creative masters of English water-colour.

By now Towne had been absent from England for about twelve months. He had greatly improved his technical powers, and stored his mind with unforgettable impressions, memories that were to haunt his art with valuable suggestions, and to be his unlimited stock in trade for the rest of his life. Nor is it difficult to imagine the effect of these encounters with the Italian scene, the Alps, and such perils as are described by Thomas Jones, on Towne's nervous temperament, and with what dramatic emphasis he related them to his friends on his return to England. An amusing but undated letter from William Jackson to Ozias Humphry written in September, 1781, throws some light on this:

Clovelly

City Art Gallery, Leeds

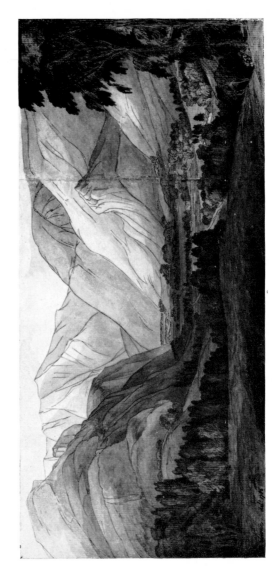

PLATE XIII

The Vale of St. John looking towards Keswick

City Art Gallery, Leeds

"As our friend Towne is returned safe, let no one ever talk of the dangers of travelling. I am sure a child of ten years old is just as capable of avoiding scrapes or getting himself out of them as he is. I hope soon (now this evening, if your information be right) to congratulate him on the happy period he has put to all his hairbreadth 'Scapes in the imminent deadly breach'. You tell me to expect much from his drawings which must be doubly valuable from the Places they represent."

It is not surprising that Humphry was impressed by Towne's Italian and Swiss drawings for they show tremendous progress on all his previous work. In those of the Colosseum, particularly, Towne rose to the melancholy splendour of the subject, and his landscapes round about Tivoli, Nemi and Naples are memorable for the artist's insight into the classical spirit of these solemn and lovely scenes. Towne himself must have regarded his Roman drawings with satisfaction for he expressed the desire that they be housed in the British Museum near the works by his friend Pars. Thus he ensured that they were a permanent and accessible memorial of his achievement as an artist. This wish was fulfilled by his friends James White and John Herman Merivale, just after Towne's death in 1816.

In the meantime Towne resumed his routine at Exeter as drawing master, obtaining commissions for replicas of his Italian water-colours, and visiting London whenever he felt inclined.[1]

There is no doubt that the artist had greatly improved his position as a result of his Italian and Swiss tour, and it was only regretted, principally by James White, that he had not remained longer in Italy. He now embarked on the most successful part of his career, lived much in Exeter, associating with the 'county' and always a welcome visitor at the great country houses as at those of his Exeter friends.

Feeling again the need of a change or scene, Towne made an excursion to the Lake District in 1786 with John Merivale and James White. Several works, notably *The Vale of St John, looking towards Keswick, Derwentwater from the South with a Storm approaching, and A View of Rydal Park* (Leeds Art Gallery), were part of the harvest of that occasion. In 1788 he resumed

[1] Towne's London addresses about this time and until 1803 throw some light on his movements. According to a sketch-book he used 79 St. James's Street in 1786. In 1789 the R.A. catalogue gives At Mr. Downman's, 5 Leicester Fields, which address (without Downman's name) continues on drawings until 1794. The relevant rate-books for these two parishes have been searched but Towne's name, as a tenant, does not appear in them. An address on a drawing of 1797 is No. 14 New Bond Street which was next to Ozias Humphry's house. In 1800 and 1803 he is at 30 Wigmore Street and in 1808, 1809 and 1810, he is at 39 Queen Anne Street West.

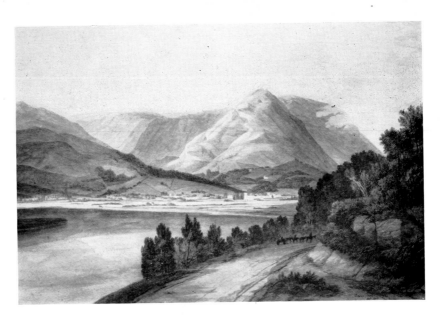

Grasmere, from the Rydal Road

City of Birmingham Art Gallery

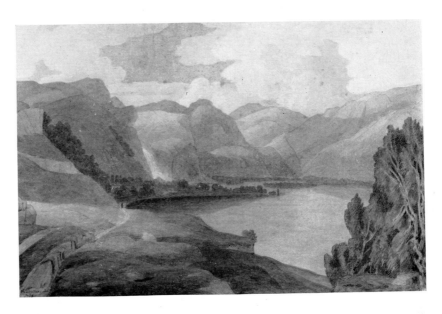

PLATE XIV

Derwentwater, looking South

City Art Gallery, Leeds

exhibiting at the Royal Academy, the picture being *A View of the Grisons near the Source of the Rhine*. By 1800 he had accumulated no small fortune, if we take into consideration the value of money in those days.

As a bachelor he did not trouble to entertain, and saved his money. An innate temperamental reserve fostered his economic mood. But did he, like some bachelors as they reach an advanced age, begin to regret the years of solitude, and hope for a belated experiment with matrimony? The fact is that, when nearing seventy, Towne made the great hymeneal decision ; and of all apparently unlikely persons married a young dancer of French extraction, about forty years younger than himself. Her name was Jeannette Hilligsberg.[1] She is described as of Exeter, and it is said that they were married in that city. A search through the transcripts of Exeter parish registers failed to produce any record of the marriage. The information as to this marriage was printed by a Mr Winslow Jones in *Devonshire Notes and Gleanings* Vol. III, 1890, p. 17, from a statement by Miss Anna Merivale. The truth is that this wedding took place in London at St Mary le Bone on August 5th, 1807, and was witnessed by J. H. Merivale and J. Forested.

Paul Oppé writes: "If she can be identified with the Madame Hillisberg whose benefit at the King's Theatre in May 1801 in the ballet of Ken-Si and Tao was commemorated by a coloured print, her profession and influence may have contributed towards his (Towne's) settling more definitely in London, which he claimed in 1803 to be his only home". There is some inconsistency here, for Towne and his wife were domiciled in Exeter in 1807. It is possible that they had a place in London as well. Towne was certainly living in London in 1806, judging by a letter supplied to me by Mr Stephen C. Merivale, a descendant of John Merivale. Dated June 26, 1806, from Lamb's Conduit Street, it is written by Mrs J. H. Merivale to her mother-in-law at Barton Place, and the following extract concerns Towne:

"Did John, when he wrote to Fanny, mention that we had been to call on Mr Towne and the treat he gave us of an exhibition of his last drawings. We asked him to dine with us last Saturday and John forgetting that 2

[1] The Enthoven Theatre Collection, Victoria and Albert Museum, has provided me with certain facts about a Mlle J. Hillisberg. She is noted as having danced at the King's Theatre, Haymarket, in "Zingari in Fiera" on May 14th, 1793, and she appeared at Drury Lane on February 19th as "Statira" in "Alexander the Great, or The Conquest of Persia." A Mlle Hilligsberg, probably the same person, appeared at Drury Lane in 1794 and at Covent Garden in 1797. On the programmes her name is printed in large capitals. She was commemorated in two engravings by J. Condé after H. de Janvry, dancing in "La Jaloux Puni" at the King's Theatre, 1793, and in "Ken-Si and Tao", 1801.

of a trade never agree asked Mr Hall a friend of his and an Artist by Profession to meet him. But we intend reverencing the Axiom more in future, as, on this Occasion it was most fully exemplified tho' we had given Mr Hall a Caution beforehand not to dispute too many of Mr Towne's profound Opinions and Observations. He could not give up his own Opinions on art sufficiently and as Mr Towne did not know his Profession but took him as he afterwards told John, for a lawyer, he thought him, I daresay, particularly Arrogant to dissent so much from HIS ideas. Tell Nancy that in spite of all this he took the opportunity to tell me that if we were even less acquainted the loss would be wholly his. He made me play to him and when I finished Corelli asked me if I understood Extempore playing. Upon my replying in the negative and his lamenting he sat down to the instrument by way of shewing me which he did by playing the chord of G natural and one or two of the chords in Unison which anyone knowing their gamut might accomplish, and accompanying them with his Voice which, unintentionally, I should suppose too, was an entirely different sound from the Instrument and very nearly ruined me in his good Graces by my being hardly able to restrain myself from laughing at the Specimen of Extempore playing and singing he exhibited but the Force of which I was obliged to tell him I saw perfectly"

The letter gives an impression of a man rather whimsical and not a little self-confident. While knowing much about his own art, he appears to have been completely deficient in the art of music.

Returning to 1805, an important event took place in the spring of that year. Towne held what was remarkable for those days, a one-man show at. the gallery in Lower Brook Street, afterwards used in the autumn of that year for the first exhibition of the newly formed Society of Painters in Watercolours. His work was described in the catalogue as A Series of original Drawings "of the most picturesque scenes in the neighbourhood of Rome, Naples, and other parts of Italy, Switzerland, etc., together with a select number of views of the Lakes, Cumberland, Westmoreland and North Wales. The whole drawn on the spot by Francis Towne, Landscape painter".[1]

The collection of 191 drawings also included two studies made in London, *From Millbank*, and *Hyde Park, study of a Tree on the ground*.

This exhibition was surely held the more firmly to establish Towne's

[1] *Art in England* 1800–1820, by W. T. Whitley, p. 93. This catalogue is printed on page 118.

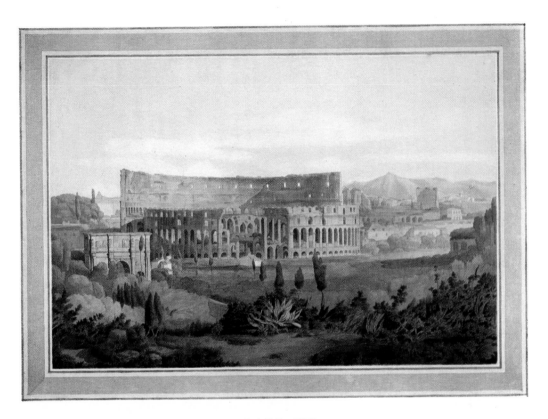

PLATE XV

The Colosseum from the Caelian Hill

with the Arch of Constantine on the left, $12\frac{1}{4}$ x $18\frac{3}{8}$ in. Signed and dated:
F. Towne, 1799. This water-colour is a variant of the same subject entitled
View of the Colosseum from the Palatine Hill with the Arch of Constantine l. *and the
Baths of Titus* r., signed and dated: Francis Towne, 1780, in the British Museum

Cecil Higgins Art Gallery, Bedford

—

position in the London art world. Throughout his career he wanted to become a member of the Royal Academy, but his detachment from the metropolis and the fact that he spent so much time painting water-colours and teaching frustrated this. He first put up for election in 1776. John Downman induced him to try again in 1797. Whitley in his *Artists and Their Friends in England*, 1700–1799 states that Towne's name was "added to the list at the last moment", but Downman omitted or forgot to support him. Towne tried again in 1798 and in 1803, but secured only one vote on each occasion, Humphry's. In fact, Towne was in the list of candidates from and including 1776 to 1803, eight times.[1]

Having written to inform Towne of his defeat, Humphry received a reply in which Towne "repudiates bitterly the stigma of being called 'a provincial drawing master', and while he probably overstates his earlier connexion with the metropolis, he was no doubt quite genuine in his claim for serious recognition as a landscape painter in oil. 'I never in my life', he says, 'exhibited a *Drawing*.'"[2]

Whatever disappointment he incurred did not prevent him from sending again to the Royal Academy, for from 1803 to 1810 he showed eight works there.

Meanwhile Towne was preparing to leave Exeter and establish himself permanently in London. A letter from James White to Ozias Humphry, dated Exeter, November 1st, 1807, reads, "Pray in your rambles through London lately have you met with our friend Mr Towne? He went from here about a month since, with the intention of taking a house in the neighbourhood of Cavendish Square; and I hear that Mrs Towne set out with her servants for London the week before last so I should hope he had found a situation, agreeable to him, and say I shall expect to hear how the arts go forward—and particularly whether Sir George Beaumont's Claude is recovered from the injury it sustained in its removal from its house to the rooms in Pall Mall"

[1] According to Farington's Diary under date of June 15, 1803, 'Francis Towne called on me to mention that he should be a candidate for Associate rank. His permanent residence is now in London. He spoke of his pupil *Abbott* as having much preparation for landscape—by having studied nature, but that he was not much acquainted with fine works of art. Towne thinks Mr Angerstein's "Marine Claude" the finest picture in the world'.

[2] *Francis Towne, Landscape Painter*, by A. P. Oppé. Walpole Society, Vol. 8. 1919–1920. The quotation is from an autobiographical letter from Towne to Humphry, dated November 25th, 1803. I have not been able to trace the original letter.

Mr and Mrs Towne were finally domiciled in London in November 1807. It is a sad fact that she died on April 16th, 1808, at the age of twenty-seven, a few months after they had set up house at 39 Queen Anne Street West. Her body was taken to Exeter and buried in Heavitree churchyard. I have come across no reference to Mrs Towne in correspondence, except in James White's letter already quoted. Is it possible that this marriage of their old bachelor friend to a young dancer raised some doubt as to its wisdom in the circumstances? Did they imagine that it was both a frivolous and dangerous adventure that could prove unhappy and interfere with Towne's career as an artist? But there is nothing to show that the marriage, brief as it was, was not successful, and a touching reference occurs to his Jeannette in Towne's Will.

Recovered from his grief, Towne appears to have painted and studied with his usual enthusiasm. Dated sketch books and individual oil paintings and water-colours are an index to his industry and travels covering Wales, Devonshire, Cornwall, Windsor, Oxford and Warwickshire until 1815. In a letter to James White, endorsed Nov. 9, 1808, Ozias Humphry writes, "In my last letter I gave you to understand that I had not seen Mr Towne:– on going casually to the British Institution in Pall Mall, I found that young [he was 68] gentleman laudably employed making a copy, half the size of the well known capital picture of Claude Loraine in the possession of the Earl of Egremont which you have often seen."

In 1810 Towne was to suffer the loss of Ozias Humphry, for we learn from a letter from William Upcott to James White, dated March 9, that "almost his (Humphry's) last request was couched in the following terms. 'William! If I should die, as I shall, for it is all over—I wish you to inform my old friend Mr White of Exeter of it, Mr Towne and Mr West'."

In the spring of 1813 Towne was involved in a law case about a property in Wales (Penkerrig) which had belonged to Thomas Jones, the artist whom he visited at Naples. A certain Captain John Dale had married one of Jones's daughters, and after his (Jones's) death, he and his brother-in-law had shared the property. Some ten years later, on the death of an intervening brother, a younger brother of Jones put in a claim. A long and expensive law-suit occurred and the claim was substantiated because Thomas Jones had not married the mother till many years after the daughters were born.

¹ *Ozias Humphry*, by G. C. Williamson, p. 205.

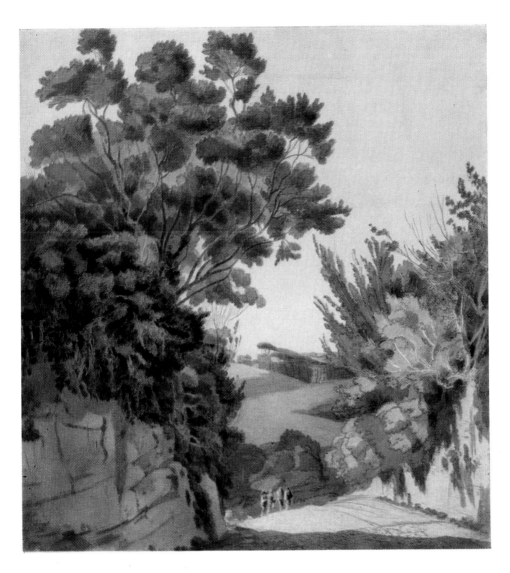

PLATE XVI

The Villa Borghese from a hollow
Road near the Arco Oscuro

British Museum

Towne gave evidence in the case which took place at Hereford. Another witness was a Mrs Flowerdew who wrote to Captain Dale on April 2nd, 1813, a letter which mentions Towne in the following terms:

"Mr Town [sic] and I finished our journey with many compliments on each side, but lest you should think that a woman never outlives her vanity I shall not repeat the fine speeches he made. I adopted your advice of sometimes adverting to the Thursday evening scene[1] when tried with his incessant talk. He certainly talks well but never did I hear anyone speak for such a length of time on a subject. I have forgotten all the rules in drawing he pointed out to me. You I believe were a more attentive scholar . . ."

This letter is as interesting a reflection on Towne's personality as the one by Mrs Merivale quoted on page 47. Both reveal Towne's self-confident mood.

In 1813, the artist's health began to fail. He had lived what in those days was regarded as a long life, and if he had not achieved some of his ambitions, notably academicianship, he had won no small measure of success as an artist and considerable material reward.

Francis Towne died at 31 Devonshire Street, London, on July 17th, 1816. His body was taken to Exeter and buried in his wife's grave at Heavitree.

The Burial Register of 1808 contains the entry "Jeannette Towne was buried April 23rd aged 27 years", and that of 1816 the entry "No. 95, Francis Towne, London, July 22. Aged 77 years. P. M. Osborne Curate."

There is an inscribed flagstone in the south aisle of the nave, near the choir, but it is so worn by the passing feet of 150 years that only the margin can be deciphered.[2]

Thus, the lovely county of Devonshire holds the dust of this fine artist who came from who knows where. Suffice it to say that Devonshire inspired him first and last, whatever his excursions to Wales, Italy, Switzerland and the Lake District. When I visited Heavitree churchyard in the autumn of 1960 in search of Towne's grave I imagined the cortège as it passed down the hill from the city and turned right into the little street leading to the church. Coming to the end of this street, a superb panoramic view over the valley of the Exe opened out before me. How often in life must Towne have looked at this wide and peaceful landscape.

[1] There is no clue to the meaning of "the Thursday evening scene".

[2] I am indebted to Dr. R. Churchill Blackie and the Rev. Edward Royle for these facts.

The artist's Will[1] is an interesting document in that it establishes some of his monetary wealth and nominates several men and women legatees in various parts of the country. First drawn up in 1810, there are two codicils dated November 24th, 1815, and May 5th, 1816.

Specific bequests amount in all to £2,775, and an important beneficiary was Mrs Isabelle Stooke, whose original bequest of £200 is increased by further sums in the codicils to £1,000 in all "for her exemplary conduct & very great attachment to my late dear wife for many years which she lived with her to her death".

Two nieces, daughters of Towne's deceased sisters, Mrs Ann Newton and Mrs Lydia Upton, received legacies. This is the only reference I have discovered as to any of Towne's relatives.

Francis Abbott, Towne's godson and second son of J. White Abbott, received £200.

The artist's old friend, Richard Cosway, of 20 Stratford Place, London, received £25 and a drawing, and John Smith, the water-colour painter, with whom he travelled back from Rome to London, received £50 and a drawing.

Such are a few of the monetary bequests.

"All the rest residue & remainder of my personal property Estate I give and bequeath to James White Esqre of North Street Exeter as a very small acknowledgment for his generous friendship & kindness which he showed me during so many years of my life for the term of his natural life and from & after his decease I give & bequeath the same & every part thereof to John Herman Merivale Esqre, No. 15 East Street Red Lion Square London his Exors Admrs & Assigns for ever and I hereby nominate & appoint James White Esqre of North Street Exeter sole Exor of this my last Will and Testament".

Among these effects were two pictures by Gainsborough.

Anna Merivale on page 186 of her *Family Memorials* writes:

"To return to the year 1816, when at the death of the old family friend, Mr Towne, the artist, my father found himself, quite unexpectedly, heir to his small property, amounting eventually to about £3,000, as well as a

[1] If gossip can be believed Towne was very reluctant to spend money. Farington quotes a remark by a Rev. Mr Patch of Exeter that Towne saved £10,000. "His economy was extreme . . . He lived on a shilling a day"

Discussing his own abstemiousness with Farington, Downman spoke of the great frugality of Towne who "by saving made a fortune". June 25, 1804.

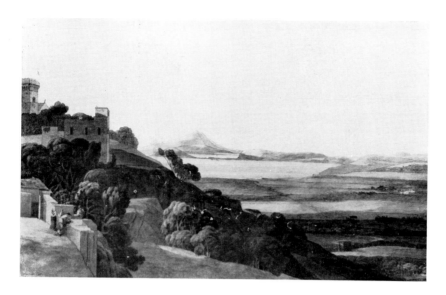

View from Tessa Aurunca

City of Leicester Museum and Art Gallery

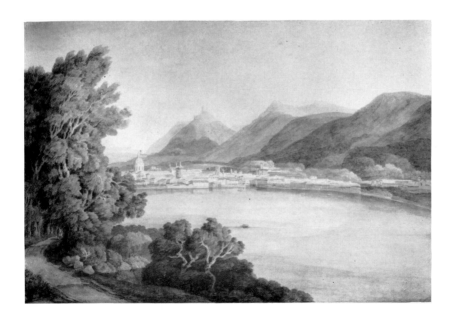

PLATE XVII

Como

Private collection *Photograph by courtesy of Messrs. Thomas Agnew & Sons Ltd.*

D

The Baths of Caracalla
City Art Gallery, Leeds

PLATE XVIII

View under an Arch of the Colosseum
British Museum

large collection of his oil paintings and water-colour sketches. It was not until the death of Mr White (to whom the life interest was left) which took place several years later, that the whole bequest came into my father's possession; but with the assistance of part of it, which was advanced by Mr White, he was enabled to move his family into a more suitable house in Little East Street, and in March 1817 to take possession of No. 15 Woburn Place, Russell Square.''

James White died in Garden Square, North Street, Exeter, on June 25th, 1825.

To be near their son and grandchildren old Mr and Mrs Merivale went to live in London, retaining, however, Barton Place as a country residence. Ultimately they lived in a house on Windmill Hill, Hampstead, and John Merivale died there in 1831.

John Downman drew Towne's portrait on two occasions, at the age of about 40 and later in life. The one dated 1780, done just before Towne went to Italy, shows an aristocratic, if somewhat effeminate face. Delicate, fastidious, reserved, there is nothing of a gregarious temperament in those features. They have a remarkable perfection of proportion, and serious expression. Nor is it surprising that Towne's work shows so careful and conscientious a style. His cast of countenance expresses a critical attitude, as well as pride and independence. Never likely to intrigue or humble himself to gain social or material advancement, he could be certain to treat with disdain any condescension or patronage from persons unequal to his own status as an artist and style as a man. It is a pleasant thought that after about a hundred years of obscurity, Towne's work emerged and took its rightful place among important achievements in art; and that descendants of the Merivale family, who had preserved the artist's works for so long at Barton Place, Exeter, witnessed the increasing renown of "the old family friend".

Exeter from Exwick

Oil on canvas, $45\frac{1}{2}$ x $63\frac{1}{2}$ in. Signed and dated 1773. This is the "large picture" mentioned in the inscription on the drawing below. It was given by Towne to James White, and descended to John White Abbott, who presented it to the Devon and Exeter Institution in 1826. Purchased by the Royal Albert Memorial Museum, Exeter, 1961.

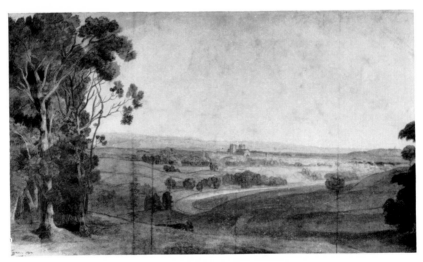

PLATE XIX

Exeter from Exwick

Water-colour $8\frac{1}{2} \times 15\frac{1}{2}$ in.

Royal Albert Memorial Museum, Exeter

A Critical Survey of Towne's Work

W E MAY REASONABLY take the year 1760 as the beginning of Towne's professional career as an artist. He was then about twenty and had been studying since fourteen. I have come across no portrait work whatever by him. The emphasis had been on landscape painting in oils; but Towne had, of course, acquired knowledge of the figure as is proved by the neat and adequate way in which he could put figures into his pictures. His subjects were pastoral scenes, mountains, waterfalls and ruins. With the exception of one work entitled a *Piece of Flowers*, all his exhibits at the Society of Artists and Free Society between 1762 and 1773 were landscapes. Whether the one entitled *A Large Landscape with a Scene in Shakespeare's Cymbeline* contained important figure interest cannot be determined, as the picture has not been traced.

Towne certainly hoped to become a landscape painter of eminence and material success, but while his contemporaries Richard Wilson and Gainsborough had all the distinction they could wish in this department of art they both found patronage too restricted to make a living by landscape work only, and had to depend on portrait painting. Ironically enough, Wilson had a struggle ultimately to exist either as portrait or landscape painter.

When Towne settled in Exeter he painted local views and the domains of Devonshire landowners, and became the drawing-master as well.

In 1773 he achieved the *Large Landscape with a View of Exeter*, so titled in the Society of Artists' Catalogue for that year, but in fact a view of Exeter from Exwick. It has a Claudian-Wilsonian sentiment, as regards the composition with trees to the left and right of the picture and a wide extensive view between them, but it lacks Wilson's imaginative and creative handling of paint. Nor has it the breadth of style of a good Lambert, or the vigorous manner of Gainsborough. Towne's technique harks back somewhat to Wootton and the earlier artists. Like his own temperament, the painting is reserved and careful, albeit the result of much study on the spot. The preliminary drawing is in the Royal Albert Memorial Museum, Exeter, and is inscribed by the artist, *No. 1. A View of Exeter taken between Exeter and*

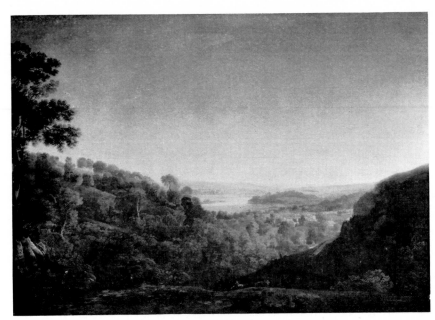

The Valley of the Teign

Oil painting, 1780

Leicester Museum and Art Gallery

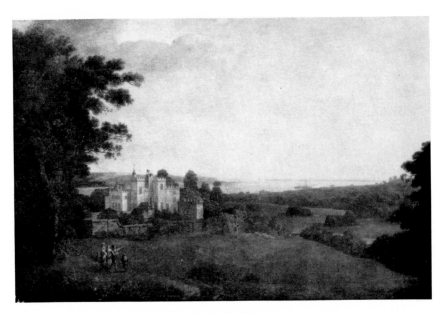

PLATE XX

Powderham Castle

Oil painting, 1777

Coll. the Rt. Hon. the Earl of Halifax

Cowley Bridge on the hill looking towards Exeter with the river on the left hand. This is the original outline that the large picture was painted from that was in the Exhibition of 1773, Francis Towne, 1787. The inconsistency of the dates may be explained by the possibility that the drawing was touched up or tinted in 1787. The oil painting was presented to the Devon and Exeter Institution in 1826 by J. White Abbott, Towne's pupil, and has recently been acquired by The Royal Albert Memorial Museum, Exeter.

Another big oil painting is the *Powderham Castle*, 1777. Comparatively unknown until it was loaned to the Treasures from Yorkshire Collections (Leeds Art Gallery, 1954) by the Earl of Halifax, it is a dignified rendering of Lord Courtenay's domain, composed with large trees in the left and right foreground, a group of little figures, the castle beyond and the estuary on the horizon.[1] It is painted in great detail, all the architectural facts being carefully recorded. The warm glow of sunshine and cool grey shadows on the castle are very exact, to give a true portrait of the place. The group of five figures in the foreground are curiously Italianate in character. Recession from the large trees to those in the middle distance is expertly handled—and a herd of deer is introduced in an appropriate place. The sky when freshly painted must have had some of Wilson's golden light.

Another oil of similar technical standard is *The Valley of the Teign* (Leicester Art Gallery), signed and dated 1780. To the dimensions of $31\frac{3}{4}$ x 45 in., and therefore much smaller than the previous two pictures, it is more concentrated, and thus more manageable within the artist's precise style.

The Exeter Art Gallery contains a small oil painting, *A Street in Rome*, signed and dated 1800, adapted from a drawing inscribed *F Towne, delt. Rome*, Octr 31, 1780 (British Museum), and it is interesting to see how closely this oil follows the original water-colour after a lapse of twenty years. Of the same date is the oil called *In the Alban Hills near Rome*, also founded on a water-colour.

The Fitzwilliam Museum has a picture, $15\frac{3}{8}$ x $20\frac{3}{8}$ in., called *A Hilly Landscape*. Considering the fact that it is dated 1780, seven years after the *View of Exeter from Exwick*, it is a surprisingly disappointing effort.

[1] The sketch for this picture is in the Earl of Devon's Collection at Powderham Castle, and is inscribed on the back, "This view of Powderham to be painted in a size four times as large each way by order of Ld. Courtenay, Oct. 22nd, 1774." The oil painting was bought by the grandfather of the Earl of Halifax as a present to his wife, Lady Agnes Courtenay.

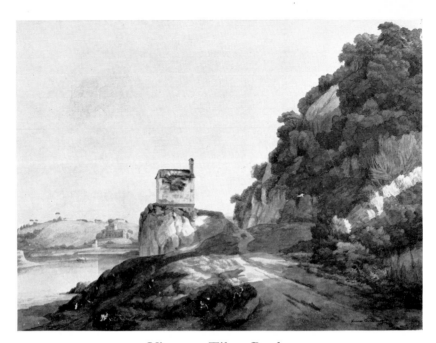

View on Tiber Banks

Royal Albert Memorial Museum, Exeter

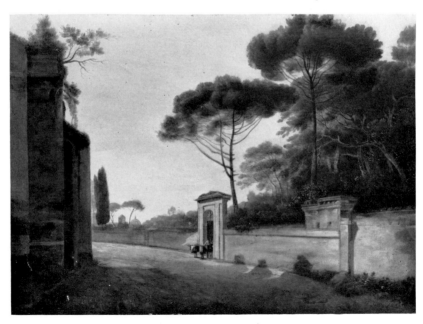

PLATE XXI

Street in Rome

Oil painting, dated 1800.

Royal Albert Memorial Museum, Exeter

Colonel M. H. Grant once possessed a charming landscape, $7\frac{1}{2}$ x $21\frac{1}{2}$ in., with a large, laboriously wrought tree to the right, and undulating distance. In his admirable book, *Old English Landscape Painters*, he writes, "it does not pretend that this part of his [Towne's] life's work has merited greater efforts at preservation than that due to quiet Landscape of an unambitious and conventional type". Towne continued to paint intermittently in oils throughout his life, and the last large and important picture to my knowledge is *A View looking up the River Exe, Devonshire*, 66 x 46 in., dated 1811.

There must be many more Towne oil paintings in existence but the few I have described give an idea of his place as an artist in oils, and though good they are not sufficiently original or personal in style to make Towne conspicuous in the English School of Landscape in this medium. One feels that, even if he had concentrated only on oils, his name like those of many other artists of average ability, would not have survived except as a matter of art historical reference.

It is to Towne's water-colours that we must look if we are to make a fair assessment of his contribution to art. Nor is it without significance that only during the last forty years has the artist been recognised as an important, if somewhat isolated, member of our water-colour school. Though the short paragraph in the *Gentleman's Magazine* for August 1816 alluded to Towne as an artist of "great eminence as a landscape painter", the allusion must have been to his oils, and in this respect would appear to be journalistic licence, especially as the obituarist ends there and does not qualify his opinion. Towne was certainly not eminent then as a water-colourist, having no popular vogue in this method, his exhibits being too few to gain him celebrity. One can assume that his one-man show of water-colours and drawings at 20 Lower Brook Street in 1805 made little impression,[1] and but for William T. Whitley's research this incident in Towne's career would have remained vague and uncertain. It was, in fact, not until the first exhibition of the Society of Water-Colour Painters at the same gallery later in that year that this medium began to be taken seriously as an art expression by critics and public generally. But that Towne had some position in the art world there is no doubt. His lapse into complete obscurity for over a hundred years is due to various factors, chief among which may have

[1] In a search through the contemporary Press for the revelant period I found no reference to this exhibition other than advertisements.

been an originality in water-colour style unlikely to appeal to the taste of his own time or to Victorian sentiment later. We must remember too that, semi-detached as he was from London during the greater part of his life, he was, in fact, although he resented the criticism, the provincial drawing-master. Finally, the bulk of his water-colours and drawings remaining in his possession at his death, and bequeathed to his friends James White and John Herman Merivale, were hidden in portfolios and cabinets at Barton Place, Exeter, until Paul Oppé discovered them there. Likewise, the two volumes of his Roman water-colours were "interred", as it were, in the British Museum.

The inscription within the first volume is illuminating:

> Presented by James White Esqre of Exeter Executor of Francis Towne Esqre, with t[]le Esqre, in compliance with the desire of []wings" should be deposited with those o[]Museum.

Towne's rec[]t is touching when we recall that the latter[]-four years. Obviously, Towne still remember[]tion in youth together.

Redgrave r[]ps a pupil of William Pars, but Paul Oppé re[]least, and probably four years his junior. T[]scarcely have been Towne's master befor[]at the age of 20 or 22". Yet Pars *was* cho[]o there. Such is proof enough of exceptiona[]ee with Redgrave. If Pars did not actually[]fluence on Towne's style as draughtsman and[]ing.

Let us look at the Grecian water-colours by Pars in the British Museum. These in the main are topographical. The Society wanted records of antiquities as carefully drawn as possible, records moreover that would form an accurate basis for engravers who were to interpret facts rather than fancies.[1] In *The Gymnasium at Troas*, showing a massive triple archway of masonry, partly hidden by dense trees and heaps of fallen stones, the building is the subject, and the trees and other incidentals merely adjunctive. The drawing throughout is in fine pen lines, and the superimposed tints tend

[1] Woollett's engravings after Pars were in Towne's possession.

66

to hide the inexpressive and haphazard style of these incidentals. In the *Ruins of the Temple of Apollo, Didymaeus from the N.E.*, the building is beautifully delineated, as are the goats in the foreground, but the rest of the water-colour is not up to the same standard. *The Arch of Mylasa* is a brilliant study of the architecture but how scratchy and careless are the foreground and trees. In the *Sepulchral Monument at Mylas*, the architecture, figures and distances are infinitely better than Pars's trees and foreground. One of his best Grecian subjects is *The Temple of Athene at Sunium*, but it is not a great water-colour. None the less, the cumulative effect of all Pars's Grecian subjects is impressive, largely because of their antiquarian interest, and any young artist with similar tastes might well respond to their style.

Then there are Pars's Swiss water-colours, *The Valley of the Lautenbrunnen*, with three rather pretty cascades, the *Lower Part of the Valley of Chamounix*, and the same subject from *The Mountain Side*, *The Glacier at Grindelwald*, and *The Glacier at Mont Furca*, which I do not doubt that Towne admired, but certainly improved on when in due time he was confronted with similar scenes.

All painters who have tried to adapt their experience of oil technique to water-colour know how extremely difficult it is to draw trees and simplify foregrounds with their innumerable problems of foliage detail, grasses and light and shade. If they use the pen with washes of tint some formula is essential unless the result is to be a meaningless confusion of lines. Studying Towne's early drawings enclosing arboreal form and foliage in his thin, wiry line we are conscious of the artist's difficulty and at times frustration. But gradually Towne redeemed his strenuous effort by an instinct for design and patterning in pure, limpid washes of tint, suggesting breadth by colour in spite of his small and artificial manner with the pen. Certainly he had more feeling for pen line as regards trees, shrubs and grasses than did Pars, but technically his drawing has nothing in common with the rich variety and freedom of Claude's pen or brush work, nor with the confidence of Alexander Cozens. He could not handle pencil or chalk with the sensitive and explicit delight in the point that Wilson, Gainsborough or Rowlandson display. Towne's drawings are not painter's drawings. They conform rather to the elements of etching, but, as he developed, this very rigidity of style, plus an instinct for pattern in tints, produced something unique in its way.

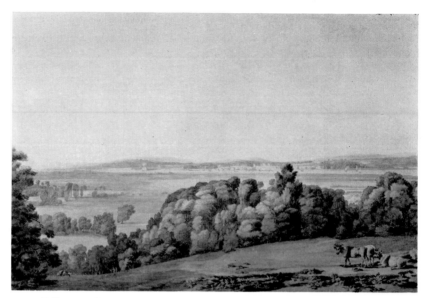

View taken near Exwell, looking towards Topsham

Coll. Sir William Worsley, Bart.

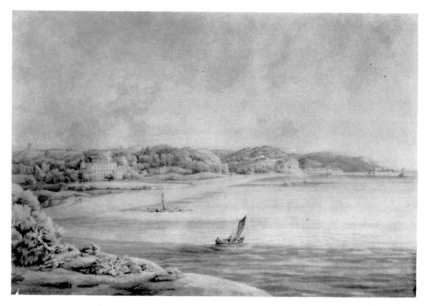

PLATE XXII

Torr Abbey

Private collection

Economic necessity forced Towne into doing water-colour topographical work. The demand for large oil paintings was limited could sell a greater number of his water-colours and augment hi y teaching amateurs to express themselves in the same way. B t attached to the already established tradition of topographi aul Sandby (1725–1809) had shown how far the water-colour be adapted to *realise* the English scene, and Francis Cotes (17 such a work as *Landscape with View of a Country Seat*, dated a and Albert Museum) had mastered the difficulties of rend with natural effect, and putting an extensive view into tonal e's immediate contemporaries, M. A. Rooker and Nicholas ere far more accomplished in the art of representation than wa

In some works, when the artist adheres to all t fore his eyes as in such landscapes as *View near Exwell, looking to psham, From the Belvedere at Powderham Castle*, and *Torr Abbey*, his eff be realistic tend to overwhelm the subject with undigested detail, an mannerism with trees and foreground is monotonous and unselective. The line is often hard and uniform, the small incidents such as cows in the foreground of the two landscapes, and the ships in the *Torr Abbey* subject being so concentrated for their size as to mar the unity of effect.

Towne's line was a means to an end, a kind of plan of regions to be filled in like a map with tints. Although he often inscribed his drawings as works "drawn on the spot" such was not his invariable method, and many landscapes were worked out with pen and tints in the studio on a detailed pencil foundation. The artist must have done a large number of monotone and tinted drawings before he went to Wales in 1777, and made replicas as occasion demanded, keeping the originals as specimens to show to possible clients, but whatever their aesthetic defects they prove an intense pleasure in the subject and the power to cover a large space of paper with pictorial interest. There is no better training in technical knowledge than to try and work out a subject to some ultimate conclusion rather than leave it as a sketch, and Towne retained this conscientious attitude from the beginning to the end of his career.

Until he was about thirty-six his life had been circumscribed by Devonshire, Cornwall and London, and it is a curious fact that on his many visits to the metropolis he does not appear to have drawn or painted much in

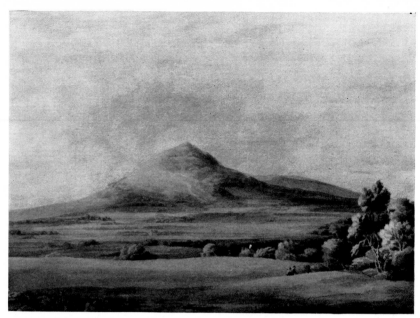

The Wrekin, Shropshire: Wenlock to Shrewsbury

Private collection *Photograph by courtesy of the Fine Art Society*

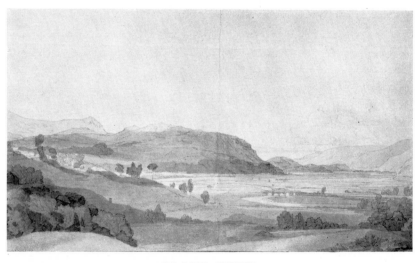

PLATE XXIII

Near Dolgelly

Coll. Leonard Duke, Esq., C.B.E.

London or *en route*. In any case, I have encountered few works during this period that come into that category. I notice from the 1951 Festival Exhibition at Exeter a Hornsey subject dated 1783 which belonged to Mr Gilbert Davis. The artist apparently was content with the subjects that Exeter and the neighbourhood could provide. Whether this shows some lack of enterprise or whether he was always too busy with his pupils and commissions for local views who knows, but there comes a time in an artist's life when a change of scene is necessary to stimulate his enthusiasm and revive his inspiration. Towne's Welsh tour of 1777 was that change of scene for it brought him into touch with grander views and provoked a latent feeling for mountain form.

Let us look at some of his Welsh water-colours. *Wenlock Nunnery* is a straightforward view of a ruin. *Near Dolgelly*, inscribed on the verso *A View of Dolgelly with part of Cader Idris*, June 30, No. 11 *drawn on the spot*, is a skilful synthesis of a vast scene, and it is interesting to compare this with Cotman's richly coloured interpretation from the same viewpoint (Fitzwilliam Museum). Towne's is like a piece of fine prose, Cotman's a poem. There is *The Wrekin, Shropshire: Wenlock to Shrewsbury*, in which the handling of the mountain and uninterrupted sweep of foreground and middle distance would appear to anticipate Girtin's breadth. Sir William Worsley's *Ludlow* is frankly an accomplished topographical study.

As Paul Oppé writes, "With the Welsh drawings of 1777 Towne's water-colours proper begin", and one defers to so astute a connoisseur of the subject, and one moreover who had the advantage of seeing fifty of those Welsh drawings at Barton Place before they were dispersed. Towne, aware that passing time demanded some additional effort, some fulfilment of an urge to improve upon all previous work, was prompted to make a special effort. Certainly, one of those Welsh works, *Salmon Leap, Pont Aberglaslyn*, strikes a forceful note of originality. It is not so much in the technique that still shows his rather timid pen structure, especially in the immediate foreground where the stones and lines of the waterfall are too delicate to be in character with so formidable a conception, but in the mass of mountain form rendered in simple flat planes rising precipitately to the top of the picture. The play of light and shade on the dark massive rock and on the waterfall is effective. But it is the artist's vision that is important. There is nothing picturesque in this water-colour, Towne seeking the essential

71

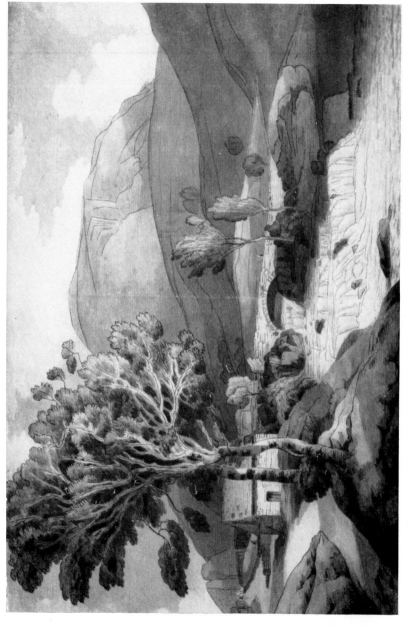

PLATE XXIV

Bridge and Waterfall near Llyn Cwellyn

Laing Art Gallery and Museum, Newcastle-upon-Tyne

anatomy of a scene almost remote from human association and comparatively immune from the aggression of time. For austere sentiment *The Salmon Leap* is remarkable in the decade 1770/1780. Apart from the method employed to express this aspect of nature, it is not a subject likely to appeal at that time to artists or collectors. This water-colour remained at Barton Place, and must have been among those unsold. A Welsh water-colour having similar stylistic characteristics is *The Bridge and Waterfall* (Laing Art Gallery, Newcastle-upon-Tyne), but its strong sunlight and more familiar architectural features, cottage and bridge, for instance, make it less bleak than *The Salmon Leap*.

On his return to Exeter the artist was occupied in assembling his Welsh sketches, adapting some of them as oil paintings and doing other works of local interest. The Royal Academy catalogue for 1779 records *A View in North Wales near Llangollen in Denbyshire*, and *A View on the River Exe, taken near the Seat of Sir Francis Drake*. In the following year he exhibited, also at the Royal Academy, two views in Devonshire.

It was in 1780 that Towne decided to go to Italy. He set forth early in September and went to Geneva, for the first drawings resulting from his tour are two of that city, *Bridge over the Rhone at Geneva, the River issuing from the Lake*, and *View of Geneva near the Confluence of the Arne and Rhone*, dated September 7th. Neither of these has any distinction, but if they were both done on the same day they prove that he was a very rapid worker. He must have spent some time in Switzerland looking at subjects and deciding to return there, before travelling on to Rome by easy stages, for the first Roman drawing, according to the artist's numbering, is dated October 16, *No. 1, Inside the Colosseum*. To the dimensions of $12\frac{1}{2}$ x $18\frac{5}{8}$ in., it is a strenuous effort to express part of the amphitheatre. That Towne was somewhat overwhelmed by this monstrous mass of stony débris is only to be expected, but that he was determined to draw the subject in detail is clear enough. Indeed, he could not discard anything, and must needs fill the foreground with niggling pen strokes. He persisted doggedly to the end of four hours, and if the result is not entirely satisfactory it is something of a *tour de force* of facts. Towne was not to be deterred from a subject that would test the skill of any artist, particularly one working with so restricted a technique. But the blending of quiet tints, light red, yellow ochre and pale green is successful in its harmonious effect.

E 73

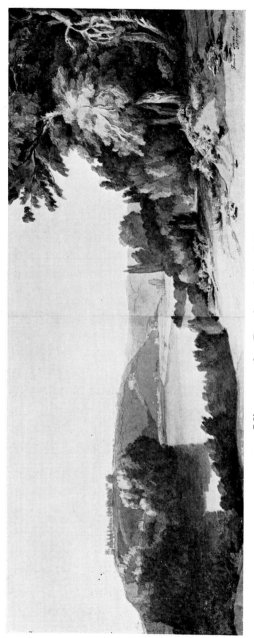

View on the Banks of the Tiber

British Museum

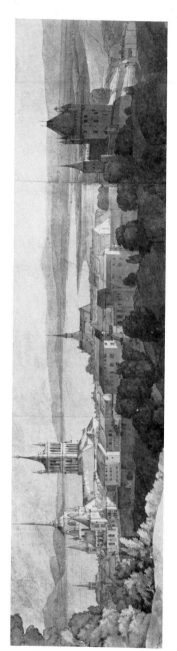

PLATE XXV

View of Lausanne

Fitzwilliam Museum, Cambridge

Perhaps it was a relief to Towne to get on to a subject that offered scope for his gift of balanced arrangement of form, light and shade, for probably on the afternoon of the same day he escaped from the Colosseum to a quiet stretch of the Tiber, and worked there on a panoramic scene, called *View of the Banks of the Tiber*. I regard this as one of the most beautiful of Towne's Roman water-colours, expressing the artist's delight in a natural scene far older than the vanity of imperial caesars, "dead and turned to clay". In this work on two sheets of paper joined, measuring $8\frac{3}{4}$ x $21\frac{1}{2}$ in., Towne has realised the importance of values and recession, from the mass of trees to the right foreground, the tranquil reflections in the river, and the tenderly drawn hills on the horizon. Though the tints are washed on a pen foundation the line is more or less hidden.

For the rest of October and during November Towne was busy in Rome learning his way about the great ruins. He soon appreciated the necessity of selecting parts of the Colosseum that made fine and dignified compositions, such as the *View under an arch of the Colosseum, and the Arch of Constantine*. Signed and dated November 18, *from 3 till 5 afternoon*, this is a lovely drawing, mostly in sepia with a pale blue sky and luminous cloud. Likewise *A Gallery of the Colosseum* is excellent, the difficult perspective of the parallel lines of arches being drawn with accurate economy. Equally assured in its graceful understanding of the facts is *The Temple of Vesta*, June 27th, 1781. A variety of sun and shade information is conveyed in flat washes of tint, from the dark wall in the foreground to the gentler tones on the temple itself. The buildings to the right and in the distance are realised with the most delicate care. A restricted colour-scheme, sepia, light red and yellow ochre, and a pale blue sky suffice to express the building in the heat of a summer afternoon.

A far more elaborate and difficult subject, however, is the *View of the Colosseum from the Palatine with the Arch of Constantine l. and the Baths of Titus, r.*, Towne being at great pains to render the immense amphitheatre as a whole, and his manipulation of lights and darks on the building according to the effect of the sun is very ingenious. The drawing, however, lacks tonal veracity, and Towne's scratchy and too detailed foreground tends to minimise the dignified mass of the architecture. It was probably intended as a documentary, a working model for replicas of the subject. The artist certainly improved on this water-colour in a version dated 1799, now in the Cecil Higgins Art Gallery, Bedford, and reproduced in Plate XV.

The View from the Palatine Hill looking towards the Pyramid of Caius Sestius is a far better work than the first version of the Colosseum aforesaid. The foreground and middle distance, though detailed, are admirably subdued by washes of dark green and brown to throw into relief the exquisite drawing of the buildings and hills on the horizon in a tranquil evening light, the sky also being very true in its gradation from grey-blue above to gold beneath.

Three versions of the *Baths of Caracalla*, two in the British Museum, numbered by Towne 33 and 35, *drawn on the spot*, and the other in the Leeds Art Gallery are instructive as showing the artist's increasing powers of simplifying complex masses of stone all but submerged in vegetation. Also he is getting used to the bright Roman sunlight, for the appeal of these water-colours is in the way he enlivens the large shadowy masses with luminous accents here and there. The Leeds Art Gallery one, inscribed Rome No. 36 *Baths of Caracalla Light coming from the right hand*, is superb in its spontaneous understanding of intense light and shade; and the simplification of the towering bulk of stone to the right.

Towne liked doing large pictures from a height in order to develop the far distance as a foil to foreground facts; and an inspired water-colour is the *St Peter's at Sunset from above the Arco Oscuro*. The eye is led beyond the trees and rocks—large, simple, dark but translucent shapes—to St Peter's, exquisitely delineated in a golden glow suffusing the wide horizon. In the matter of drawing buildings his pen line has now become really expressive.

An entirely different Roman subject is *A Hollow Road near the Arco Oscuro*, very original in design with complex tree and foliage form on either side, the whole welded together by washes of dark green and brown, save where a patch of sunlight on the road gives the key to the atmospheric effect. The cumulus clouds against the blue sky are subtly considered as shapes to enrich and bind the design together as a whole.

We are so familiar with Towne's pen line formula that it is interesting to encounter Roman water-colours without it. *The Palatine Hill looking towards the Baths of Caracalla*, and *Arch and Débris in a Ruin on the Palatine*, are in every way as accomplished as his water-colours on a pen foundation. Indeed, it is pleasant to see that he could dispense at will with his wiry line, particularly as regards foliage and foreground. The second of these two pictures, though extremely detailed, with a striking effect of sunlight on a ruined arch,

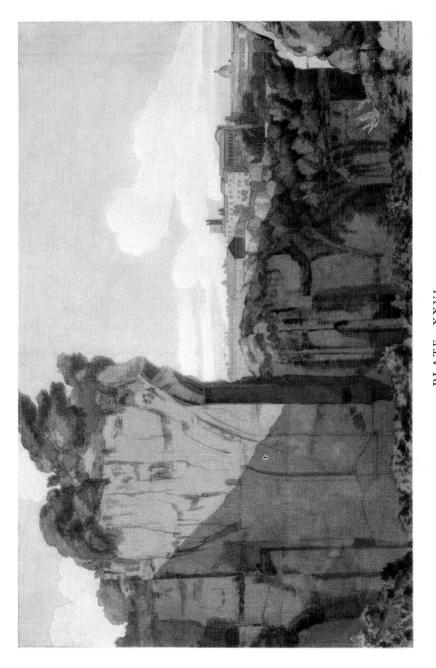

and a small patch of bright blue sky beyond, improves in delicacy because the whole is drawn with the brush. Inscribed from 10 till 2 o'clock the amount of work achieved in four hours is quite amazing. A third pure water-colour is *Part of the Baths of Titus*, and is remarkable for a strong colour scheme.

Wandering along the Tiber bank one summer evening Towne's mood responded immediately to the effect of the sun illuminating a temporary wooden bridge over a hollow in the foreground. This prosaic structure is transformed by the brilliant light into something rich and strange, the mysterious landscape background being subordinated in cool colour to emphasize this bridge. The simple sky gradated from green-blue at the top to gold on the horizon strikes one as being absolutely true to time and place.

We have it on the authority of Thomas Jones that Towne arrived in Naples on March 8th, 1781 and remained there till April 3rd, Jones acting as his cicerone. How many works he achieved in that short time I am not sure, but a large water-colour entitled *View on the Side of a Valley looking towards a hill, with a distant glimpse of the Bay*, peasants under trees in the left foreground, is numbered 11 in the artist's handwriting. It is replete with interest from the two graceful trees in the foreground lit by the sun in warm contrast to the shadowy blue of the hill to the right, and the village half in sunlight and shadow surmounting it. The sea on the horizon is indeed a "glimpse" but sufficient to add an enchanting factual note to this classical scene. Another Neapolitan subject is the *Convent of S. Eufebio, near Naples*, commonly known as the *Convent of S. Efremo*, neither a successful design nor convincing atmospheric effect. The composition is somewhat haphazard and unselective and the result is therefore disjointed, as if Towne had lost his way in too much pictorial intention. The animals in the foreground are badly drawn and far too small to be in scale, a defect that occasionally occurs in Towne's incidentals. There is a curious detachment about them. In some of his drawings they do not take their place with convincing actuality or they have an eerie, ghostly look, as in the religious procession from the *Emperor's Seat*, a Colosseum water-colour. This may have been deliberate here. Again, in *A Gallery of the Colosseum* two phantom-like figures are hurrying up the steps. Maybe, the solitary in Towne felt that human figures tended to disturb the beauty of the landscape or the elegiac solemnity of silent, time-haunted buildings long dissociated from human affairs.

With what creative excitement Towne entered into the landscape in the Sabine and Alban Hills round about Rome, choosing the month of May when this neighbourhood is touched by the magic of vernal luxuriance. Thanks to constant practice and acute observation the series of tree drawings done during that month show a great advance on any previous work of the kind. The one entitled *At Tivoli, Wooded Hills round a valley, Sun breaking through from the r.* has a certain splendour of its own. Having made an elaborate preparatory drawing, Towne waited until the foreground tree was caught in a brilliant light before applying his tints, but how beautifully this tree stands out in contrast with the large dark one to the right and the quiet blue colour scheme of the middle distance woodland and hills beyond.

The artist is fascinated by the tortuous form of the olive tree struggling into life from the rocky soil as in *Rocks and Trees, Tivoli*. And *In a Wood near Albano* light plays the dominating part in the mysterious gloom, Towne revelling in the effect of the sun on that old, ruined trunk, still, however, crowned with foliage. This water-colour is fantastically natural. If we study it carefully, we see that the truth of the sun striking from the left is confirmed in the shadows across the road to the right.

Two spontaneous sketches *Tivoli* and (Exeter Art Gallery) *Near Rocca del Papa* come into this series of fine tree studies in light and shade.

A magnificent drawing, mostly in monochrome, is the one inscribed No. 64, June 28th, *Lake of Nemi*, and shows with what intelligence Towne worked out his design in the linear style now completely under his control. It is particularly interesting as revealing how far the artist went with the pen and simple grey washes before applying colour. The *View of Tivoli from the Neighbouring Hills*, No. 31, is also Towne at his best. Both are in the British Museum.

The artist's energy was undiminished by the heat of the summer, and he was continuously working out of doors during the last weeks of July. In some water-colours it was his habit to start at dawn, for the one entitled *L'Ariccia July 11th, Morning Sun breaking over the church and buildings*, is absolutely convincing as to that atmospheric moment, the first light of day flooding the elevated cupola, buildings and foreground road, juxtaposed with the dark, rich green shapes of the trees still holding the shadows of the night. It is interesting to note that, according to Towne, a copy of this picture was painted in oils for James Curtis Esqr. From the artist's dating,

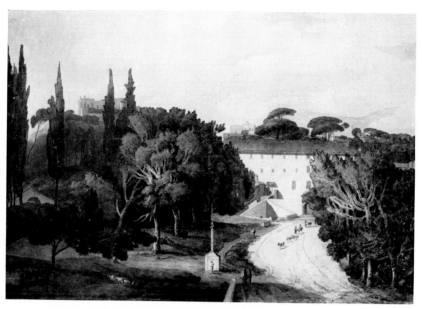

Convent of S. Eufebio, near Naples

Victoria and Albert Museum

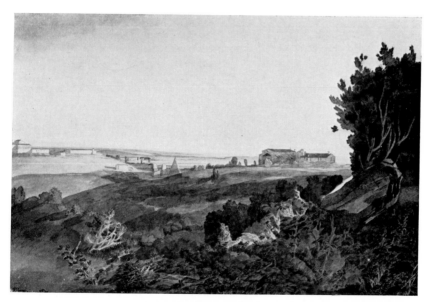

PLATE XXVII

View from the Palatine Hill, looking towards the Pyramid of
Caius Sestius

British Museum

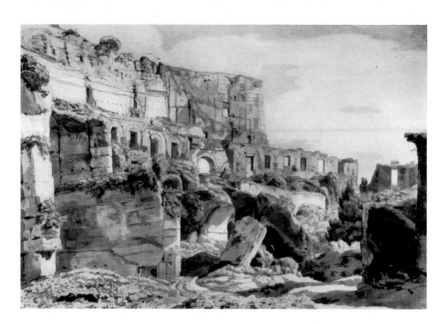

Inside the Colosseum, October 16, 1780

British Museum

PLATE XXVIII

A Road near the Arco Oscuro

British Museum

PLATE XXIX

Lake of Nemi

British Museum

PLATE XXX

Rocks and Trees at Tivoli, 1781

Coll. D. L. T. Oppé, Esq., and Miss Armide Oppé

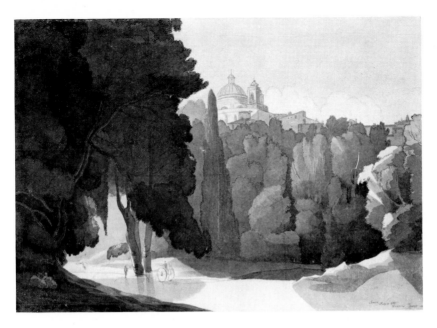

L'Ariccia. Inscribed Larice, July 11, 1781. Morning sun
breaking over the church

British Museum

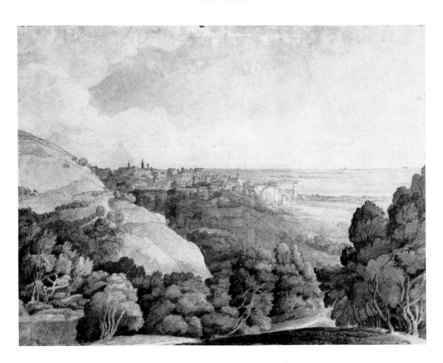

PLATE XXXI

View of Tivoli from the neighbouring hills

British Museum

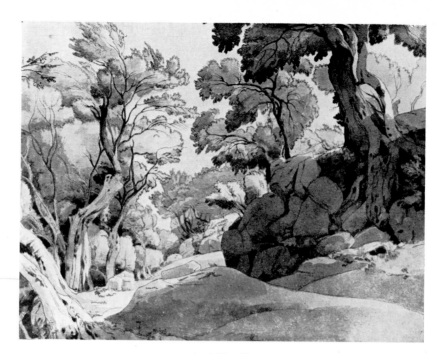

At Tivoli

Royal Albert Memorial Museum, Exeter

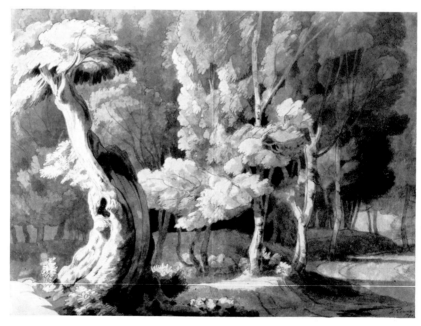

PLATE XXXII

In a Wood near Albano, 1781

Coll. D. L. T. Oppé, Esq., and Miss Armide Oppé

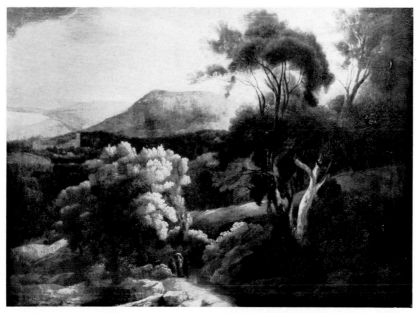

At Tivoli, wooded Hills round a Valley. Oil painting, 1800, founded
on the British Museum Water-colour (*beneath*), May 16, 1781

Royal Albert Memorial Museum, Exeter

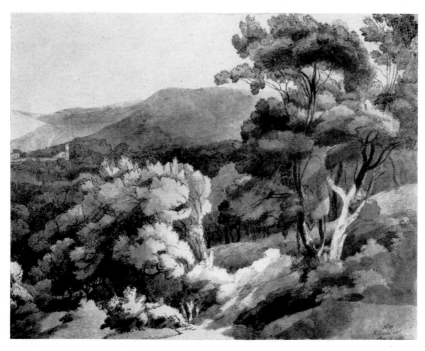

PLATE XXXIII

British Museum

the next day he painted a picture of the *Lake of Albano*. He was in Rome on the 18th for a large water-colour, *The Arch of Septimus Severus* is so inscribed. There is also one of the *Roman Forum*, and Towne's resolution in coping with such large and difficult architectural subjects in the hot Italian sunlight is commendable, but he is happier when he combines buildings with landscape and chooses morning or evening effects. These two late works in Rome were probably done for reference should Towne be commissioned to make replicas in due time.

I doubt if any artist could have worked harder or accumulated so many interesting water-colours of Rome, Naples and the neighbourhood during the few months that Towne was there. He was probably needing a rest, or at least a change, but he was hardly likely to get a rest on the journey north to Switzerland. Travelling in Italy in the eighteenth-century was hazardous and fatiguing almost beyond endurance. Thomas Jones and James North-cote have left us the most painful descriptions of the discomfort experienced, riding in what were little better than carts over execrable roads, or even on the backs of mules where the tracks were not to be negotiated otherwise; and the inns were mostly intolerable.

At any rate Towne and John "Warwick" Smith, who accompanied him, were safely in the neighbourhood of the Italian Lakes towards the end of August. Towne's energy is obviously restored, for among many subjects that he did of this neighbourhood are the *Town of Lugano* and *View of Lake Lugano*. I regard them as among the most impressive of Towne's mono-chromatic effects. They have the inspiration of the sketch, plus profound knowledge and it is interesting to compare their vigour with the deliberate and highly finished water-colours that he did from them after his return to England (Plate 34). These monochromes, which are in Sir William Worsley's Collection, were the prelude to the splendidly simple *Waterfall between Chiavenni and Mount Splügen*. Towne's mind, completely obsessed with the stark grandeur of this scene, has mastered its essential structure and significance in bold convincing strokes, entirely devoid of rhetoric. This is the original and best of three versions. Then there is the very large *Mer de Glace*, also, in my opinion, the first version of this subject done for the sixth Lord Clifford of Chudleigh.

Sir William Worsley's Townes comprise as illuminating a cross-section as one could wish to see, covering all the artist's periods and phases from

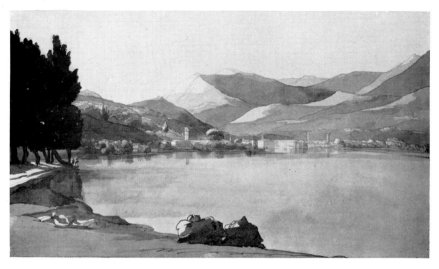

Town of Lugano, 1781

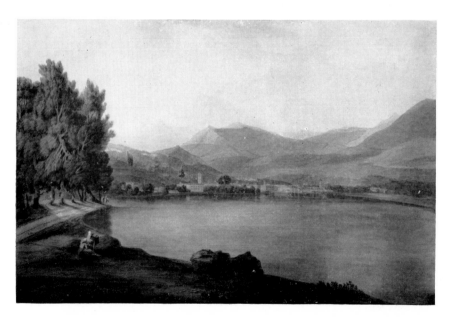

PLATE XXXIV

Town of Lugano
Adapted from the previous sketch and dated 1787

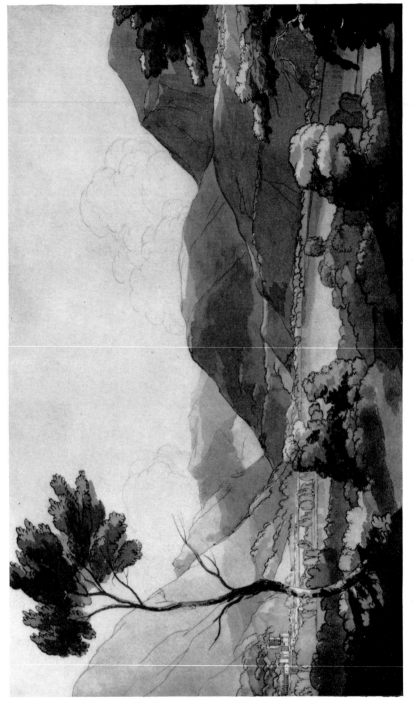

PLATE XXXV

Lake of Lugano, taken from Mendris

Coll. Sir William Worsley, Bart.

Photograph by permission of "Country Life"

Ludlow Castle

PLATE XXXVI

Vauxhall Stairs

F

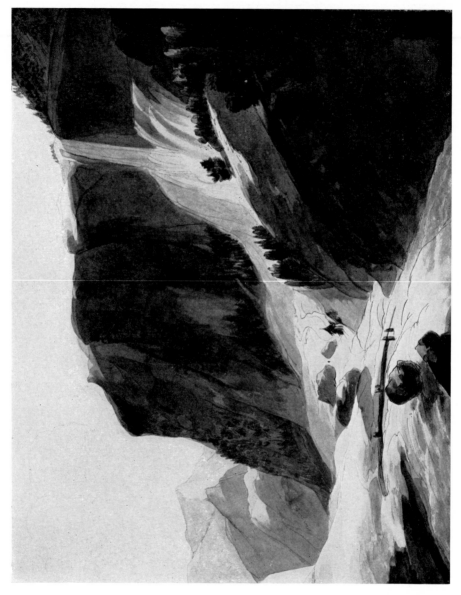

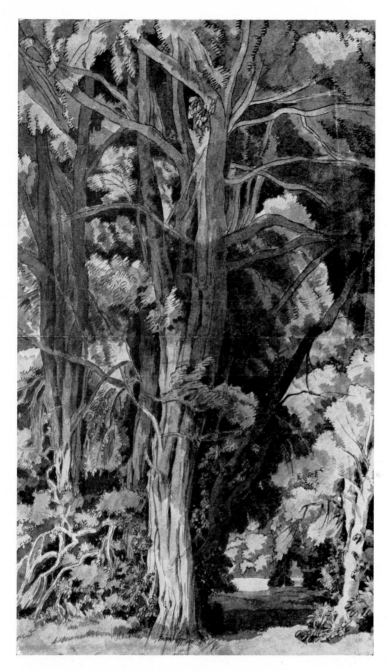

PLATE XXXVIII

The Fir Tree

Coll. Sir William Worsley, Bart.
Photograph by permission of "Country Life"

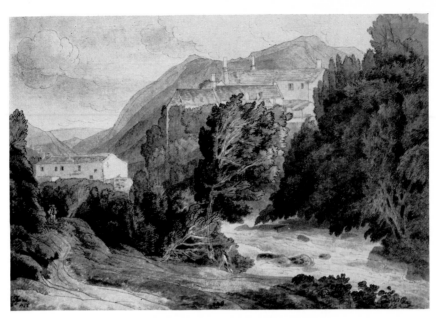

Head of Lake Windermere, 1786

Private collection *Photograph by courtesy of Messrs. T. Agnew & Sons Ltd.*

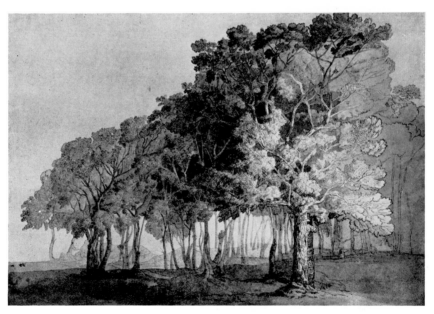

PLATE XXXIX

Werington Park

Coll. Sir William Worsley, Bart. *Photograph by permission of "Country Life"*

1777 to 1813, with the appropriate accent on his Italian and Swiss tour. The *Ludlow Castle* is among Towne's best topographical works, and his careful treatment of panoramic actualities is proved in the *View taken near Exwell, Looking towards Topsham*, dated 1779, already mentioned. And here let me remark that it was precisely Towne's tireless discipline as a draughtsman in the first place that made it possible for him to improvise eventually on natural facts and interpret them with such poetic power. In Sir William's collection we can trace the artist's development and the inspirational force derived from his visit to Italy and Switzerland. If the *Tivoli Waterfall and Town*, dated 1780 is still somewhat factual, he is certainly trying to experiment without using the pen substructure, and I suspect that in this instance he came under the influence of "Warwick" Smith.

At Hovingham Hall we can be with Towne when he made three little water-colours of the *Villa Adriana* on the 20th and 22nd of May, 1781, in which he has caught the haunting solitude and melancholy of this relic of the great and humane emperor, Hadrian. The Lake District water-colours are two small Windermere views, both done on August 16th, 1786, and a Keswick dated 1805. The *Fir Tree in a Wooded Park*, dated 1799, is a magnificent tree study, comparable with the superb study of a tree and fallen trunk in the Hyde Park subject, dated 1797 (Toledo Museum, U.S.A.). A particularly interesting example is *The Grove, Werington Park*, for it is quite unlike Towne's usual manner with arboreal form and foliage, but none the less a very sensitive and conscientiously drawn affair. Finally, it is instructive to follow Towne's movements nearer London in such notes, *Vauxhall Stairs from Millbank*, 1797, two Windsor Castle sketches, *From West India Docks*, and *Looking towards Greenwich Hospital*—all dated 1813, and no doubt leaves from a sketch-book.

Towne painted many examples of waterfalls in England, Wales, the Lakes, Italy and Switzerland, notably *Waterfall, Rhaiddu, N. Wales*, (Sir Bruce Ingram's Collection), *Waterfall near Ambleside* (Oppé Collection), *Cascade at Windermere, Cascade at Rydal Hall* (Ashmolean) and that immense effort *Falls of the Terni* (33 x 20$\frac{3}{4}$ in.) in the British Museum, signed and dated 1799, inscribed by the artist *The Cascade of Terni drawn on the spot by Francis Towne*, 1781. It is in six pieces joined together. The artist probably made the component parts on the spot and assembled them as a whole in 1799. Its unity of effect in the circumstances is quite remarkable but it is too

large to sustain the medium and is more like scene-painting than nature. The smaller ones are much better poetic realism, especially the *Waterfall near Ambleside*, in studying which, one can almost hear the roar of the cascade and violence of the wind in the trees.

Reverting to Towne's journey from the Italian Lakes over the Splügen pass into Switzerland three small water-colours, $6\frac{1}{8}$ x $8\frac{1}{4}$, are particularly significant. *Le Reve*, dated August 28th, 1781, and two of the Splügen (Oppé Collection) hold our attention by reason of their summary style and intense feeling. In their limited dimensions the artist has not failed to convey the enormous scale, shapes, and relative distances of these Alpine rocks. One stands with him on this pass contemplating the magnitude and solitude of nature at her remotest—a place that, in those eighteenth-century days, daunted as it excited the boldest travellers. In company with John "Warwick" Smith, Towne absorbed the scene. Both expressed it in water-colours, and a version by Smith in the Cecil Higgins Gallery, Bedford, is the measure between their styles and temperaments. Good as Smith's picture is, it has little of the formidable sentiment that can be felt in Towne's. These small Splügen pictures are premonitory. The spirit of the Alps is already moving the artist to make the final, creative effort of his grand tour.

Arrived at Geneva by September, a water-colour of *Lac Leman* with great tree forms in the foreground, rocks to the right and mountain shapes across the lake is a pleasant *ensemble*. Purely topographical is the one drawn and tinted with the utmost delicacy entitled *View of Lausanne*, dated September 10th, 1781.

Some time in September the artist wandered into the heart of the mountains near Geneva. Confronted by these stupendous forms, it is as if his conscience had become suddenly and irresistibly aware of things infinitely older than the oldest of ruins, things of eternal rather than temporal significance, having no relation to the brief span of recorded history and the drift of human generations. The decline and fall of empires, so much a part of eighteenth-century intellectual and poetic preoccupation, were but an incident as compared with the vast geological structures that bore witness to the very creation of the universe.

Therefore Towne did not see *The Source of the Arveyron* so much as a place to be identified on the map or recorded in conventional pictorial accents, but as a symbol of the inscrutable force behind all phenomena. Signed and

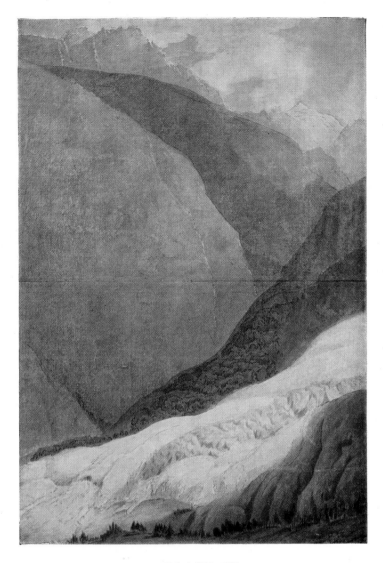

PLATE XL

The Source of the Arveyron

$12\frac{1}{4}$ x $8\frac{3}{8}$ in. Signed and dated: F. Towne, 1781, and inscribed on the
back: No. 52—A View of the Source of the Arviron drawn by Francis
Towne Sept . . . 1781. The most celebrated water-colour by Towne, this
has been widely exhibited and written about since it first appeared at
the Grafton Galleries in 1911. It has appeared twice at the Royal
Academy, in the Winter Exhibition of 1934, and in the Diploma
Gallery Exhibition of Paul Oppé's Collection, 1958

Coll. D. L. T. Oppé, Esq., and Miss Oppé

Colour plate by courtesy of Messrs. A. & C. Black

dated: F. Towne, 1781, and inscribed on the back *No. 52, A View of the Source of the Arviron drawn by Francis Towne Sept. . . . 1781*, there is no reason to think that this inspired work (Oppé Collection) was not done on the spot, for as far as I am aware there is no sketch for it in existence.

We can but try to imagine Towne seated alone somewhere in this solitude contemplating a subject that wholly obsessed him. He is fascinated by primordial shapes and colours —the white and menacing glacier moving between the two dark foreground rocks to the right. Immediately above the glacier, the wooded incline offers a suggestion, at least, of living growth, but all is purposely subdued lest any mood of familiar sentiment conflict with Towne's mood of awe. In the middle distance two austere mountain shapes curve down into the valley, the foremost one tinged by sunlight, the one beyond subtly shaded the better to throw into relief a line of peaks, one of which on the extreme right is covered with eternal snow lit by the sun. A small patch of blue sky with a white cloud shape is the ethereal note in an infinite conception. Formal as is the design and unrelated to realism, no factual representation could convey the mystery of this Alpine sublimity so well. In this work, no larger than $12\frac{1}{4}$ x $8\frac{3}{8}$ in., Towne has gone beyond any artist of his time in expressing both the spirit and substance of mountain grandeur. These mountains and glacier, recreated in pen and tints, cast a spell on us, the enduring spell that the scene cast on the artist a hundred and eighty years ago. Once having looked intelligently at this water-colour it is quite impossible to forget it.

The second *Source of the Arveyron with part of Mont Blanc* is not so imaginative as the first. It is a compromise between realism and decorative improvisation, but it is still original and distinguished. The artist has drawn the chaos of jagged ice blocks and ice pinnacles on the extreme right with more or less factual observation. There is a sinister cavern in the foreground, and a large brown rock to the right partly lit by the sun. Wooded slopes in the middle distance divide the light glacial form from the conical shape of Mont Blanc. Leaving more space in this version for the sky Towne has been able to echo the light of the ice forms with large cloud shapes. More in accordance with the appearance of things, the drawing of the glacier is less impressive than in the symbolised version. Paul Oppé suggested that this water-colour might have been influenced by a Japanese print. I do not think so. It is the logical extension of Towne's vision and manner of balancing

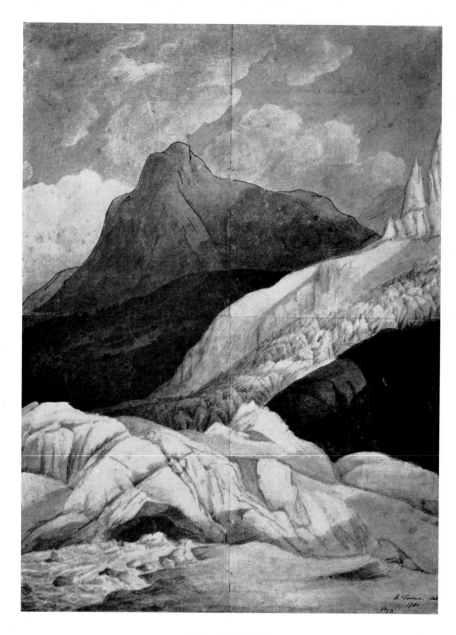

The Source of the Arveyron: Mont Blanc in the background

Victoria and Albert Museum

his outlined shapes with light and dark tints, and reducing form to stark simplicity.

Another Alpine water-colour is *Mer de Glace* (Aberdeen Art Gallery) to the dimensions of $23\frac{1}{2} \times 34\frac{3}{4}$ in. signed and dated ?1793, founded on a sketch made in September 1781, inscribed by the artist, "*No. 9. Glaciere taken from Montanvert looking towards Mont Blanc, September 16, 1781, 12 o'clock Light from the right hand*". It is an extensive improvisation on rock and ice form receding into the far distance and a fertile arboreal foreground to the right. The size of this water-colour is disadvantageous, and it therefore lacks the passionate concentration to be seen in the two previous pictures. It is possible that Towne, in doing this work, was thinking of Pars's *Mer de Glace, Chamounix*, as both works have something in common, though Towne's is more austere and without figure interest. These glacier water-colours were among the last that the artist did in Switzerland, for before the end of September 1781 he was, according to the letter addressed to Ozias Humphry by James White, back in England. From the same letter we learn that Humphry was much impressed by the works that Towne had done while he was abroad. It would be interesting to know what his other artist friends in London and his west-country patrons thought of his Roman and Swiss drawings. Unless there are letters that I have been unable to trace their silence is somewhat baffling, and it is strange that no publisher was forthcoming to have them engraved, the best way of increasing an artist's reputation in the eighteenth-century. James White must have approved them, even while regretting that Towne had not made a longer stay in Italy, and is quoted as saying that Exeter "was no place for an artist". What does this mean exactly? Towne had not done badly in the cathedral city. White was perhaps thinking of his friend's wider renown.[1] In hope of this Towne may then have decided to spend more time in London, but whether he lived half the year in the metropolis and half in Exeter as has been stated, little is heard about him until 1786, and then only on account of his work in the Lake District in that year when he went there with his friends James White and John Merivale. Industrious as ever, he achieved fifty water-colours and monochromes, but none repeat the force and originality of the Swiss subjects or the serene beauty of the Italian ones. The spell

[1] As regards contemporary fame, Towne was in a position analagous to Cotman, isolated for most of his life in Norwich. When he took up the post of Professor of Drawing at King's College he wrote to his son John Joseph, "If you wish to be an artist you *must* leave Norwich for nothing can be done for you there".

Waterfall near Ambleside, 1786

Collection, D. L. T. Oppé, Esq., and Miss Armide Oppé.

In Hyde Park, study of a Tree on the Ground

Toledo Museum of Art, U.S.A.

on him is not so potent as the Alpine or Roman experience. While retaining his sculpturesque attitude to form he is more concerned to make his scenes recognisable. *The Lake at Grasmere*, once in the collection of Miss Buckingham, is characteristic of the place. Yet the artist's style, save for stronger outlines as in *Loughrigg, Ambleside*, appears to revert to that of *The Salmon Leap, Pont Aberglaslyn*, of ten years previously. *The Vale of St. John*, inscribed on the verso of the old mount *No. 36, 5 o'clock in the afternoon, light from the left hand A View taken in the Vale of St. John looking towards Keswick, August* 17, 1786, is a dramatic effect in light and shade but lacks subtlety and spatial values. Small as these Lake District mountains are when compared to the Alps, Towne's manner makes them look like little hills. Nor can the *Derwentwater looking South* be regarded as a good work. The design is confused by too many shapes tending to break the rhythm and dignity of the subject. The large extent of the foreground lacks interest, but the bleak and lonely sentiment characteristic of the Swiss works persists. These Lake District water-colours, however, were a useful addition to his collection of subjects for possible clients.

Conspicuous among a large number of new sketches are various important works such as the 1793 *Mer de Glace* (Lord Clifford's Collection), and the replica in the Aberdeen Art Gallery, and many Roman and Italian subjects. In 1797, the artist produced a magnificent drawing of *Trees in Hyde Park*, inscribed, *This Drawing taken in Hyde Park June* 19*th*, 1797, *on the spot;* and it may be said to be Towne's finest tree study of all. It is stupendous in its intensity, a veritable consummation between the artist and nature. Marvellously detailed, Towne's original vision survives the picture's incessant rendering of the facts. Though an entirely different subject from his Italian and Swiss water-colours, it stands worthily beside them. Exhibited first in Towne's 1805 show, it is now in the Toledo, U.S.A., Museum of Art.

Other memorable water-colours done during the 1790's include *In Kensington Gardens*, and *Netley Abbey* (Oppé Collection), Mr Tom Girtin's *Modern Bridge at Narni*, and *The Colosseum from the Caelian Hill* (Cecil Higgins Collection). From 1800 to 1815 Towne was still busy adapting or improvising on works done in Italy, Switzerland and the Lakes. An 1809 Sketchbook (Fitzwilliam) containing 30 water-colours, chiefly of Devon and Cornwall, indicates a visit in that year to long familiar scenes. But between 1808 and 1815 he exhibited several oil paintings at the British Institution,

five of which would appear to have been founded on Italian themes. His most ambitious late painting was the large 1811 one *View Looking up the River Exe*, probably the picture exhibited at the British Institution in 1812, and now in Mr. Antony Gibbs's Collection; in which case it proves that Towne, until the last years of his life, retained his enthusiasm for and interest in the medium with which he began his career.

Conclusion and Summing Up

TO SUM UP, Francis Towne was a competent painter in oils but far more personal and creative in pen and transparent tints. He fostered his own style in this medium, and unlike Turner and Girtin in their early work he was not obviously influenced by anybody; but as I have already indicated he was impressed by Pars's technique and emotional approach to the subject. When working with John "Warwick" Smith in Italy (and it is clear from Smith's water-colours presented to the British Museum in 1936 that they painted several Roman subjects in company) Towne occasionally introduced richer colour, not for the better, for instance, *The Temple of Concord*. It may be that Smith's style moved him in certain works to dispense with the pen line, but only temporarily. Comparing Smith's *Temple of the Sybil from below the Falls* with a view by Towne of the same subject there is some similarity, and the simple, impressionistic and naturalistic handling of trees on the cliff side in sunlight may have prompted Towne to a looser interpretation of such incidents in works of his own. But at the age of forty, with his own manner ingrained the influence was not profound enough to change his style fundamentally. He had progressed slowly but surely for twenty years, detached from the prevailing current of topographical work. In the main he was more decorative than realistic, and his originality is precisely in this quality —the power to make harmonious patterns or shapes in colour on drawings done direct from nature. The 'drawn on the spot' habit is very important, and gives Towne's work authority and truth, as regards landscape particularly. Otherwise his decorative genius might have become lifeless and artificial.

Towne's mind was essentially classical, and his emotions were disciplined rather as the emotions of contemporary poets such as Thomson, Gray and Collins. Indeed Gray's words in regard to his own poetry "that what he aimed at was extreme conciseness of expression, yet pure, perspicuous, and musical" could apply to Towne's art. To extend the poetic analogy, and it is not yet sufficiently recognised how deep an effect English poetry had on English water-colour painting, Towne's pictures at their best have the technical restraint and meticulous sense of finality of good odes. There are

infinite ways of "describing" buildings and landscapes in water-colour. Towne's was obstinately his own, and he could not look at things through the eyes of other men. We do not know his opinion of the works of his contemporaries, but we can surmise that he admired the water-colours of Pars and was deeply impressed by Richard Wilson's and Claude's oil paintings. Towne probably copied several Claudes, and it is recorded that, as an old man of 68, he copied one belonging to Sir George Beaumont in the British Institution exhibition of 1808. If, as Paul Oppé wrote, Towne's *water-colours proper* (my italics) began on his Welsh tour in 1777, which would seem to be so as I have encountered none that are dated before that year, the artist's work in this method derived somewhat late from monochrome drawings made as working models for his oils. In any case, such a Welsh water-colour as *The Salmon Leap* establishes a focal point in his achievement. Maybe, after that Welsh tour, Towne became aware that pen and tints had potentialities that could be developed independently of his oil painting style, not only aesthetically but from the point of view of finding more clients. Resolved to go to Italy Towne took this step, momentous for so unadventurous a personality, in 1780. Among the ruins of ancient Rome and the lovely environment of the hill country round about he was happily inspired. His work from the beginning of his contact with Rome improves greatly. He is more ambitious and more imaginative than previously, but his technique was ready for such emotional expansion. It is fortuitous that Towne did not go to Italy before he was capable of interpreting the scenes that moved him. Had he gone when he was twenty he could not have achieved the series of fine water-colours that he left to the British Museum. Most artists who went there in the eighteenth-century stayed several years, but one year sufficed for Towne to turn an artist of average ability into one of exceptional achievement. Fully conscious of this opportunity Towne worked with astounding industry, determined to make the most of his time, untrammelled by economic necessity, the exacting commission and the pedestrian round of teaching. He enjoyed the chance to express himself for the sheer delight in what he could see and feel. Working in this way Towne became truly himself. He was able to indulge to the full his love of nature, and the silent, deserted ruins of the Italian genius. Although Towne's course of life had never been "desperate" as was Edgar Allan Poe's, he could have sung with that poet,

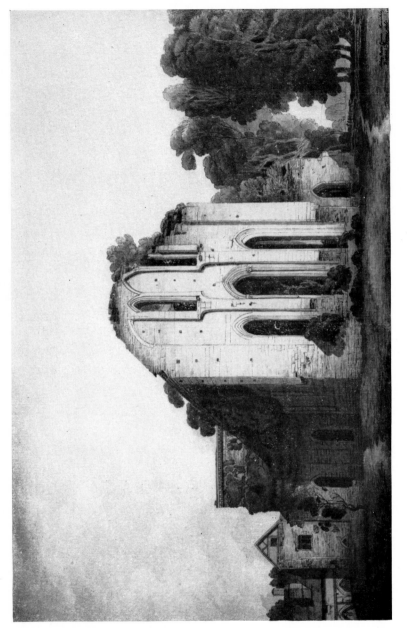

PLATE XLIII

Valle Crucis Abbey

National Museum of Wales, Cardiff

On desperate seas long wont to roam,
 Thy hyacinth hair, thy classic face,
 Thy naiad airs have brought me home
 To the glory that was Greece,
 And the grandeur that was Rome.

For apart from the love of beauty in all its manifestations, the artist's or poet's problem is the desperate imperative to create something of perfect significance, something that will endure and interest generations to come long after he has ended his brief and hazardous mortal span of existence.

There are artists to whom the classical tradition and sense of continuity it implies, is of paramount importance. There are others equally gifted who do not need this incentive. In Towne's case, I venture to say, it was a necessary part of his destiny. His one grand tour was enough. Had he stayed longer in Italy I doubt if he could have improved on the work that he did in the short time he was there. Coming up from Rome to the Italian lakes and over the Alps into Switzerland, the change of scene was so abrupt that his meditations and the work that resulted therefrom are the logical extension of a mind replete with wonderment, and a hand exceedingly sure of itself. The impact of these immensities of nature on his somewhat timorous character fascinated him as a child might be fascinated by something marvellous, fearsome yet irresistible. Looking at them with the eye of his mind, Towne became, as it were, a medium, or *nuncio*, interpreting a message much as an inspired poet will write from a kind of occult and inexplicable directive. Everything that Towne had seen before could be related to human experience, having its place in recorded time, part of the calendar of history or of nature's seasonal ebb and flow. Student of nature as he was, amateur of ruins, the landscape and the crumbling Italian amphitheatres, decaying temples and broken bridges —the "bric-a-brac" of long dead empires —had become his familiars. The Alps were "masterpieces" far beyond comprehension, but they touched some chord in his being momentarily ready to utter a singular response. Like all works of real poetic quality, *The Source of the Arveyron* pictures are mysterious both in spirit and deliverance. They are unique for he never improved on them, nor did he develop from these sincere and truthful abstractions.

An artist's career, of course, does not progress in orderly sequence. Like a temperature chart it has its heights of aesthetic success and valleys of

failure, and there is no accounting for them. While constant practice will assure progressive technical facility it will not command inspiration. Towne had his crowded hour of glorious life, by which I mean a period when he saw and felt phenomena clearer and more profoundly than before. He was seldom again to scale the height of intuition and enthusiasm of that productive year in Italy, 1780–1781.

Towne's work among the English lakes in 1786, while admittedly more experienced than water-colours done in England before he went abroad, is not as impressive as his Italian and Swiss water-colours. The question is not so much one of difference in subject, for all subjects, however grand or commonplace, are capable of great interpretation, but one of feeling. It would appear that Towne after the age of fifty was content to rest with whatever laurels he had gained and resign himself to a profitable routine as artist and drawing-master in Exeter and London; and in wandering about the country seeking subjects for expression in a style that had become invariably accomplished.

Unlike Turner, Girtin and Cotman, whose several styles are the result of experiment, Towne restricted himself to a method that was incapable of further development, and became crystallised in its efficiency. But it assured him, within its limitations, a definite measure of originality. Therefore in criticising Towne little purpose is gained by discussing the styles of his forerunners and contemporaries. One could write an ingenious and verbose disquisition on where he differs from Taverner, Skelton, John "Warwick" Smith, Paul Sandby, John Robert Cozens and later masters. Such would only tend to obscure rather than illuminate Towne's qualities. But as Towne has sometimes been coupled with Cozens, it is useful to meditate on this. All artists who are primarily concerned to communicate their love of nature intelligibly to the world at large (there are many today who are not so concerned) are impressed by works possessing the hall-mark of sincerity and distinction. It would be interesting to know whether Towne actually saw Cozens's 1776 drawings of Switzerland and the 1778 ones of Italy. If he did, I am sure that he went abroad without the slightest intention of plagiarising Cozens, but may well have borne them in mind as exceptional examples of poetic interpretation of the themes he himself was about to express. The question would have been one of emulation of merit rather than of style. His own manner, as I have already written, was mature. In

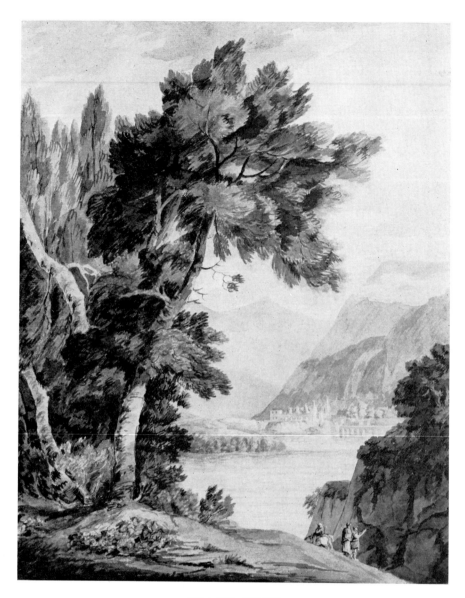

PLATE XLIV

Lac Leman

Private collection *Photograph by courtesy of the Fine Art Society*

this respect, it is pertinent to compare Towne's *View of Tivoli* (plate XXXI) with the drawing by Cozens from almost identically the same position, reproduced in the Walpole Society, Volume 23 (plate X) and Towne's *Lake of Nemi* with any of Cozens's versions of Diana's Mirror as the ancients called it. Towne's *Tivoli*, in its precise pen transcript and subtle patterning of light and dark, as well as the sky admirably appropriate to the design as a whole, is in the classical mood, and I venture to say is a better design than Cozens's. The same could be said about Towne's version of the *Lake of Nemi* (plate XXIX), as contrasted with many done by Cozens. But design is not the whole of the story. Where Cozens excels Towne is in his passionate response to the transient moods of nature. He is more profoundly moved, more impulsive, less careful than Towne, so much so that we can make allowances for or even ignore defects in composition obvious enough in some of the Nemi subjects reproduced in the Walpole Society, Volume 23. If a few works by Towne have some affinity with Cozens's style, notably as regards tree drawing, and I refer particularly to the *Lac Leman* plate, *View at Geneva near the Confluence of the Arne and Rhone*, and *Landscape with Waterfall*, the similarity would appear to be coincidental rather than intentional.

Both artists were devoted adherents of nature, and working direct from her in the same medium it would be surprising if their efforts to express truth in so limited a method as water-colour and pen did not occasionally coalesce. If Towne could not do what Cozens could do, neither could Cozens achieve what Towne achieved. Their individuality was impregnable.

Paul Oppé's remark that Towne was in a sense a primitive of water-colour painting is penetrating and just. The artist's original vision and technique survived the exceptional speed and facility that he early acquired. There is never any reason to mistake a Towne water-colour for any other master's work. Girtin's and Turner's early water-colours have often been confused. Some of Cotman's show Girtin's influence clearly. Early Varleys can resemble Girtin. I have seen examples by Bonington, Boys and Callow that are so much alike as to be indistinguishable. Towne "kept very much to himself" as the saying goes, a solitary in art as one feels he must have been in life, devoted to his Muse and to very few carefully chosen friends.

Another point is that his style is more appreciated today than it was in his time, and that can be attributed to the fact that he was primarily interested

in form, design and simple shapes of quiet, limpid colour. The obviously picturesque never really appealed to him. Towne's work at his death could have had little influence on the younger men who were to establish a school of water-colour painting second to none in the history of the art. His show in London in 1805 may have had some effect on Cotman if he saw it, but Cotman, young as he was then, had already done some of his finest works, and occasional similarity in formal design is more likely to have been the result of coincidence.

As to Towne's pupils, John White Abbott is the best, and very good he is, although he came so completely under the spell of his master as to make his water-colours quite often indistinguishable. The fact is that artists outside the prevailing tradition as Towne was remain rather isolated, and do not create a school. It requires one of exceptional genius to follow their style, emerge as personalities in their own right and ultimately produce something genuinely creative. I know of no great water-colourist working in the nineteenth century or since who can be said to have been influenced to any important extent by Towne.

All in all Towne must have had a large number of pupils throughout his long life but none developed into a conspicuously great artist.

W. Mackinnon is recorded as having been a pupil of Towne. He is represented by one water-colour in the Victoria and Albert Museum, and two in the British Museum.

A Devonshire subject—*Ruin in Moonlight*—by Susanna Buller, very much in Towne's style, dated 1790, was sold at Messrs. Appleby's in the spring of 1961.

Another pupil whose work has survived was Annabella Rowe; and of course there were members of the Merivale family at Barton Place.

Mrs. Flowerdew and Captain John Dale come to light in the letter quoted on page 55.

It is a moot point whether John Baverstock Knight (1785–1859), that most accomplished of West of England amateurs, ever studied the works of Towne. Knight's style certainly has something in common with Towne's.

LETTER FROM FRANCIS TOWNE TO
RICHARD COSWAY

St Peter's Church Yard,
Exeter,
Dec. 21st, 1800.

Dear Cosway,

 I hope you have enjoyed your health since I last saw you and that you availed yourself with a change of scene the last summer, which was certainly a fine one. I have done myself the pleasure of sending you a Turkey and pot of Devonshire cream this morning by the Balloon Coach, which goes from the Hotel Exeter, and Inns at the Saracens-Head, Snow Hill and should be delivered at your house tomorrow. I hope that you will receive 'em safe, and that they will prove to be of the very best. I shall be glad to hear from you as soon as you can, and likewise to hear from you the present state of the Arts and Artists in these *times* as 'tis but too true that I never saw or knew such before, every necessary article of Life is so raised here that it's not to be believed but by those only who know the fact, and where it will end God knows! I came down to Exeter the latter end of last July and excepting one day have remained here ever since, but I want a change of scene. I intend being in London some time in March next. I desire to be remembered to Mrs Cosway in the kindest manner and wish you both a happy new year when it comes, remaining your sincere Friend

(Sgd.) FRANCIS TOWNE.

To: Richard Cosway, Esq.,
 Stratford Place,
 Oxford Street,
 London.

Note.—Dr R. Churchill Blackie, Curator of the Royal Albert Memorial Museum, Exeter, to whom I am indebted for a copy of this letter and permission to print it, writes, "No doubt his (Towne's address) at St Peter's Churchyard is Mol's Coffee House, where later John Gendall had his school".

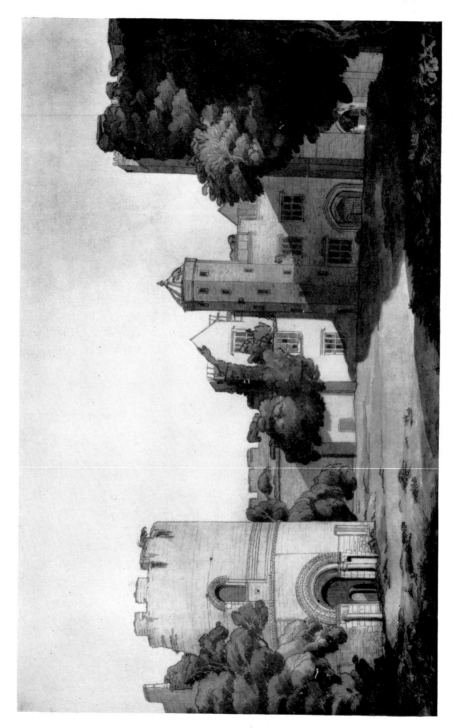

PLATE XLV

A View in Ludlow Castle

City of Birmingham Art Gallery

FRANCIS TOWNE'S EXHIBITS AT THE ROYAL ACADEMY AND ELSEWHERE DURING HIS LIFETIME

EXHIBITS AT THE SOCIETY OF ARTISTS

At Mr. Koon's, James Street, near Brook Street, Grosvenor Square

1762 A Landskip, Its Companion, a piece of flowers

1767 View of a mill at Werrington, Devonshire
A landscape

At Mr. Pars's, Percy Street, Soho

1769 A landscape: after nature

1770 A large landscape
A small landscape
A small landscape

1771 A View near Exeter
A View near Exeter
A View near Exeter

1772 A large landscape
A small landscape
Elected Fellow of the Society of Artists

1773 A large landscape (with a view of Exeter)
A small landscape

Note: The D.N.B., and Bryan both spell the name *Towne*, but in all cases in the Society of Artists catalogues it is spelt *Town*.

EXHIBITS AT THE FREE SOCIETY

From Longacre

1763 A large landscape with a scene in Shakespeare's *Cymbeline*

From Opposite Beaufort Buildings, Strand

1766 A Waterfall
A landscape

EXHIBITS AT THE ROYAL ACADEMY

At Mr. Pars's, Percy Street

1775 A small landscape after nature
 A small landscape, its companion

Exeter

1779 A View on the River Exe, taken near the seat of Sir Francis
 Drake, Devonshire
 A View in North Wales, near Llangollen in Denbyshire
1780 View in Devonshire
 View in Devonshire

From 78 St. James's Street

1788 View in the Grisons near the source of the Rhine

At Mr. Downman's, 5 Leicester Fields

1789 View taken near Martinach in Switzerland
 View taken on the Lake of Como
1792 A View on the Banks of the Tiber at Rome
1793 A view in Neptune's grotto of the Sybil's temple at Tivoli
1794 A view of St. Peter's, Rome

From Exeter

1796 A Landscape
1797 A view of Mynwydd-Mawr fall, North Wales
1798 Fall of the Cayne, North Wales

30 Wigmore Street

1800 View at Rome—afternoon
 View at Tivoli—morning
1803 View of the Passage over Mount Splügen in the Alps

39 Queen Anne Street West

1808 A Landscape and figures
 The cascade at Tivoli
 Mont Blanc
 The City and Lake of Como
1809 A view of Netley Abbey
 View at Grasmere, in Westmoreland
 View of the Chateau de Glerolles, on the Lake of Geneva
1810 A farm near Henley-on-Thames

EXHIBITS AT THE BRITISH INSTITUTION

From 39 Queen Anne Street West

1808 At Tivoli
 The Walls of Rome
 Near the source of the Rhine
1809 The Ruins of La Bathia, near Martigni
1810 A view on the Banks of the Tiber near Ponte Molle, Rome
 Exeter

From 32 Devonshire Street

1811 A view near Vicovarro, of part of the Convent of St. Cosimato,
 with the modern bridge on the Anio, and part of the Claudian
 Aqueduct
1812 A view looking up the River Exe
1815 Near Exeter
 Fall of the Cayne in Merionethshire

FRANCIS TOWNE'S ONE-MAN EXHIBITION IN LONDON, 1805

Catalogue of the Exhibition of Original Drawings, at the Gallery, No. 20 Lower Brook Street, Grosvenor Square. A series of the most picturesque scenes in the neighbourhood of Rome, Naples and other parts of Italy, Switzerland, etc., together with a select number of views of the Lakes, in Cumberland, Westmoreland and North Wales. The whole drawn on the spot by Francis Towne, Landscape Painter.

1	Canon-teign, Devonshire
2	Canon-teign, Devonshire
3	Newport in Cornwall
4	In Werington Park
5	In ditto ditto
6	Okehampton Castle
7	Berry Castle
8	On the river Teign, Devonshire
9	Cliffs and Sea near Exmouth
10	A Study of a tree blown down in Peakmore Park
11	A Quarry in ditto
12	By the ditto in ditto
13	By the ditto in ditto
14	Ditto ditto
15	From Millbank
16	From ditto
17	Hyde Park, Study of a tree on the ground
18	A wood and rocky Scene
19	Bridgnorth Castle in Shropshire
20	The Wrekin in ditto going off of a storm
21	Ditto ditto ditto
22	Wenlock Nunnery in Shropshire
23	Ditto ditto

Views in North Wales

24	Aberddwla in North Wales
25	Mantanogg in ditto
26	Mackynlleth in ditto
27	Banks of the Dee
28	Ditto
29	Ditto
30	Salmon Leap at Pont Abberglaslin
31	Denbigh Castle
32	Llyngwellyn, Caernarvonshire
33	Mynydd Mawr, ditto
34	Near ditto
35	Caernarvon Castle, built by Edward I
36	The Road going over Penmaen Mawr to Conway

Scenes in Cumberland and Westmoreland

81 Windermere near Low-Wood
82 Ditto
83 At Ambleside
84 Elter Water
85 Lake of Wyburn in Cumberland
86 Coniston Lake, Lancashire
87 Near the turnpike coming from Low Wood to Ambleside
88 Vale of St. John
89 Elter Force
90 Rydal Water
91 At Ambleside
92 The Bouder Stone in Burrowdale
93 Ditto
94 Burrowdale Chapel
95 At Ambleside coming from the Cascade in the Groves
96 Cascade in the Groves
97 Ditto ditto
98 Grasmere, in a gold frame and glass

Views in Switzerland

99 Near the Source of the Rhine
100 Near Glaris
101 Going up Mount Splugen
102 A View at Geneva
103 Near ditto
104 A view of the source of the Arveron
105 Chateau de Bloney near Vevey, at the Head of the Lake of Geneva
106 A view near Mount Splugen
107 The source of the Arveron
108 Near Glaris
109 Chateau de Glerolles near Vevey on the Lake of Geneva
110 Yanaise in Savoy
111 Aiguebelle in ditto

Views in Lombardy on the Lakes

112 On the Lake of Lugano
113 On the Lake of ditto
114 Besoni on the Lake of ditto
115 Ditto
116 The Town and Lake of Lugano
117 Near the source of the Rhine
118 A view near the Chateau de Chillon at the head of the Lake
 of Geneva, in a gold frame and plate-glass
119 Mont Blanc, in a gold frame and large glass;
120 Lake of Maggiore
121 Ditto
122 Ditto

120

Views in Italy

Scenes in the neighbourhood of Rome

163	Part of the Baths of Titus
164	Inside of the Coliseo; this edifice is of Travertina stone
165	Ditto ditto
166	Ditto ditto
167	Ditto ditto
168	Ditto ditto
169	Inside of the Coliseo
170	St. Maria Nuova, and the Ruins of the Temple of the Sun, and Arch of Titus
171	Inside of the Coliseo
172	Claudian Aqueduct
173	From the Palatine Mount
174	On the Palatine Mount
175	On ditto
176	On ditto
177	On ditto
178	On ditto
179	Temple of Minerva Medica
180	A view of St. Peter's, with the Vatican and Belvedere, taken near the Arco Oscuro
181	Baths of Caracalla
182	Tarpeain Rock
183	Ruins of the Baths of Titus
184	Coliseo
185	Arch of Septimus Severus, in the Forum, with the Temple of Concord, near the back front of the Capitol
186	The Forum
187	St. Efremo Vecchio, at Naples
188	Coming down from Capo di Monte, at Naples
189	St. Maria a Monte, at ditto
190	Grotto of Posilipo at ditto
191	*Additional in MS.* The fall of the Anio at Tivoli

1. *This catalogue of Towne's exhibition is dated* 1805 *only, but it was probably held early in that year, for a notice appeared in the Literary Magazine for February, p.* 102 *to the effect that the exhibition would be opened shortly.*

2. *There is a MS. catalogue in the British Museum Print Room: Drawings of Rome by Francis Towne. It is watermarked* 1815 *and* 1816 *and lists* 56 *items, all Roman subjects with the exception of Nos.* 1 *and* 2: " *Views at Geneva ".*

A CATALOGUE OF WORKS BY FRANCIS TOWNE IN PUBLIC AND PRIVATE COLLECTIONS

While every effort has been made to trace all the artist's works, and to make the list as accurate as possible, there are a number of pictures, particularly oils, that have eluded discovery. The following record, however, comprises the large majority of the artist's water-colours and drawings.

TOWNE'S WORKS IN PUBLIC GALLERIES AND INSTITUTIONS

BRITISH MUSEUM

1. ALBUM, containing drawings, chiefly of Rome and neighbourhood.

 (1) (a) BRIDGE OVER THE RHONE AT GENEVA. The river issuing from the lake; evening light. Signed *F. Towne delt.* (*Drawn on the spot,* 1780.)* Pen and water-colour $8\frac{1}{4} \times 10\frac{3}{4}$ in.

 (b) VIEW AT GENEVA NEAR THE CONFLUENCE OF THE ARNE AND RHONE. Signed and dated *F. Towne delt.,* 1780, *No.* 2. (*Drawn Sept.* 7, 1780.) Pen and water-colour $8\frac{3}{8} \times 10\frac{3}{4}$ in.

 (2) (a) ON THE BANKS OF THE TIBER, NEAR PONTE MOLLE. Signed and dated *F. Towne delt., Rome, Oct.* 17, 1780, *No.* 3. (*Oct.* 17, 1780. *From* 10 *o'clock till* 1.) Pen and water-colour $8\frac{1}{4} \times 10\frac{5}{8}$ in.

 (b) BANKS OF THE TIBER, NEAR PONTE MOLLE. Signed and dated *F. Towne delt.,* 1780. (*Drawn on the spot,* 1780, *from* 3 *till* 5 *afternoon.*) Pen and water-colour, $8\frac{1}{4} \times 15\frac{7}{8}$ in.

 (3) (a) VIEW IN THE CAMPAGNA. Signed and dated *F. Towne delt., Rome, Oct.* 26, 1780, *No.* 5. (2 *miles from Rome, going out at the Porta Pia. From* 10 *o'clock till* 1.) Pen and water-colour, $8\frac{1}{4} \times 16\frac{3}{8}$ in.

 (b) PART OF THE ANCIENT ROMAN WALL BETWEEN PORTA SALARIA AND PORTA PINCIANA. St. Peter's in the distance and Count Perucchi's villa in the foreground r. Signed and dated *F. Towne delt., Rome, Oct.* 31, 1780, *No.* 6. Pen and water-colour, $8\frac{1}{4} \times 10\frac{3}{4}$ in.

 (4) (a) VIEW OUTSIDE ROME. The temple of Bacchus in the distance r. Signed and dated *F. Towne delt.,* 1780. (*From* 10 *o'clock till* 2.) Pen and water-colour, $9 \times 12\frac{3}{4}$ in.

 (b) TEMPLE OF BACCHUS, TWO MILES FROM ROME. Signed *F. Towne, Rome, No.* 8 (1780). Pen and water-colour, $9 \times 12\frac{3}{4}$ in.

 (5) (a) VIEW NEAR ROME, TWO MILES FROM THE PORTA SALARIA. Signed and dated *F. Towne delt., Rome, Oct.* 30, 1780, *No.* 9. (*From* $\frac{1}{2}$ *past* 2 *o'clock till* 5.) Pen and water-colour, $8\frac{1}{4} \times 10\frac{1}{2}$ in.

* The inscriptions in brackets are taken from a MS. catalogue recording notes on the backs of the drawings.

(b) VIEW FROM THE MARTINELLI VINEYARD TWO MILES FROM PORTA PIA, ROME. Signed and dated *F. Towne delt., Rome, No.* 10, *Nov.* 2, 1780. (*From* 10 *till* 1 *o'clock.*) Pen and water-colour, $8\frac{1}{4} \times 10\frac{5}{8}$ in.

(6) INSIDE THE COLOSSEUM. Signed and dated *F. Towne delt., Rome,* 1780, *No.* 1. (*Oct.* 16, 1780. *From* 11 *till* 3 *o'clock.*) Pen and water-colour, $12\frac{1}{2} \times 18\frac{5}{8}$ in.

(7) VIEW ON THE BANKS ON THE TIBER. Signed and dated *Francis Towne delt, No.* 2, *Oct.,* 1780. (*Drawn on the spot.*) Pen and water-colour, $8\frac{1}{4} \times 21\frac{1}{2}$ in.

(8) (a) 'TOMB OF PLAUTUS,' NEAR TIVOLI. Signed and dated *F. Towne delt.,* 1781. Pen and water-colour, $7\frac{1}{2} \times 9\frac{5}{8}$ in.

 (b) A SEPULCHRE BY THE ROADSIDE GOING FROM ROME, PONTE LAMENTANA (NOMENTANO ?). Signed and dated *F. Towne delt., Rome, No.* 20, *Dec.* 12, 1780. (*Drawn on the spot. From* 2 *o'clock till* 4.) Pen and water-colour, 11 × $12\frac{7}{8}$ in.

(9) (a) TIVOLI, FROM BELOW THE WATERFALLS. Signed and dated *F. Towne delt.,* 1781. (*Drawn on the spot.*) Pen and water-colour, 10 × $15\frac{1}{2}$ in.

 (b) A DISTANT VIEW OF TIVOLI. Signed and dated *F. Towne delt.,* 1781. (*Drawn on the spot.*) Pen and water-colour, $9\frac{3}{4} \times 15\frac{1}{2}$ in.

(10) INSIDE OF THE COLOSSEUM, FROM THE EMPEROR'S SEAT, LOOKING TOWARDS THE THE PALATINE HILL. Signed *Fr. Towne delt., Rome,* 1781, *No.* 11. (*Drawn between* 11 *and* 2 *o'clock.*) Pen and water-colour, $12\frac{1}{2} \times 18\frac{1}{2}$ in.

(11) VIEW UNDER AN ARCH OF THE COLOSSEUM. Looking to the Palatine Hill and Arch of Constantine. Signed and dated *F. Towne delt., Rome. No.* 12. *Nov.* 18, 1780. (*From* 3 *o'clock till* 5 *afternoon.*) Pen and water-colour, $18\frac{1}{2} \times 12\frac{1}{2}$ in.

(12) VIEW FROM THE PALATINE HILL. Signed and dated *F. Towne delt., Rome, Nov.* 20, 1780. *No.* 13. (*From* 12 *o'clock till* 2.) Pen and water-colour, $12\frac{1}{2} \times 18\frac{1}{2}$ in.

(13) A HOLLOW ROAD NEAR THE ARCO OSCURO. Signed and dated *F. Towne delt., Rome, Nov.* 28, 1780, *No.* 14. Pen and water-colour, $12\frac{5}{8} \times 18\frac{5}{8}$ in.

(14) VIEW ON THE SAME ROAD LOOKING TOWARDS THE VILLA MEDICI. Signed and dated *F. Towne delt., Rome, Nov.* 25, 1780. No. 15. Pen and water-colour, $12\frac{5}{8} \times 18\frac{1}{2}$ in.

(15) A GALLERY OF THE COLOSSEUM. Signed and dated *F. Towne delt., Rome,* 1780, *No.* 16. Pen and water-colour, $12\frac{3}{4} \times 18\frac{1}{2}$ in.

(16) A ROAD BETWEEN GARDEN WALLS, NEAR THE ARCO OSCURO. Signed and dated *F. Towne delt., Rome, Nov.* 29, 178[0] *No.* 17. Pen and water-colour, $18\frac{5}{8} \times 12\frac{3}{8}$ in.

(17) THE VILLA BORGHESE FROM A HOLLOW ROAD NEAR THE ARCO OSCURO. Signed and dated *F. Towne delt.* 1780 *Rome, No.* 18. Pen and water-colour, 13 × 12 in.

(18) ENTRANCE TO THE VILLA LUDOVISI. Signed and dated *F. Towne delt. No.* 19, *Dec.* 9, 178[0]. Pen and water-colour, $18\frac{1}{4} \times 12\frac{5}{8}$ in.

(19) A GALLERY OF THE COLOSSEUM. Signed and dated *F. Towne delt. No.* 20, *Rome* 1780. (*From* 11 *till* 1 *o'clock.*) Pen and water-colour, $12\frac{1}{2} \times 18\frac{1}{2}$ in.

(20) A Gallery of the Colosseum. Signed and dated *F. Towne delt. Rome, No.* 22, 1781. Pen and water-colour, 12¼ × 18½ in.

(21) View of the Colosseum from the Palatine. With the Arch of Constantine l, and the Baths of Titus r. Signed and dated *F. Towne delt., Rome* 1781 Pen and water-colour, 12⅜ × 18⅜ in.

(22) The Palatine Hill looking towards the Baths of Caracalla. Signed *F. Towne, Rome No* 24 (*Jan.* 3, 1781. *From* 9 *till* 12 *o'clock*). Water-colour, 12⅝ × 18⅝ in.

(23) In the Colosseum. Signed *F. Towne delt.* *No.* 25 *Rome.* (*From* 2 *till* 5 *o'clock*). Pen and water-colour, 18⅝ × 12⅝ in.

(24) At Tivoli. Wooded hills round a valley; sun breaking from the r. Signed and dated *No.* 25 *F. Towne delt., May* 16, 1781. Pen and water-colour, 15 × 19¾ in.

(25) Ruins and Buildings on the Palatine. Signed and dated *F. Towne delt., Rome No.* 26, 1781. (*Feb.* 6, 1781.) Pen and water-colour, 12½ × 18⅝ in.

2. Album containing drawings made in and near Rome.

(1) Ruins on the Palatine, looking towards the Aventine. Signed *F. Towne delt., No.* 27. (*Feb.* 8, 1781.) Pen and water-colour, 12½ × 18⅝ in.

(2) Arch and Débris in a Ruin on the Palatine. Signed *F. Towne delt. Rome No.* 28. (*Feb.* 9, 1781. *From* 10 *till* 12 *o'clock.*) Pen and water-colour, 18⅝ × 12¾ in.

(3) The Claudian Aqueduct, near the Arch of Constantine, looking towards the Palatine. Signed *F. Towne delt. Rome No.* 29. (*From* 10 *till* 12 *o'clock.*) Pen and water-colour, 12⅞ × 18⅝ in.

(4) The Palatine Hill from Steps of the Temple of Antoninus in the Campo Vacino. Signed *F. Towne delt., Rome No.* 30. (*From* 12 *till* 4 *o'clock.*) Pen and water-colour, 12⅞ × 18⅝ in.

(5) Part of the Baths of Titus. Signed and dated *F. Towne delt.,* 1781, *No.* 31, *Rome.* (*Drawn on the spot from* 10 *till* 1 *o'clock.*) Water-colour, 12¾ × 18⅝ in.

(6) The Baths of Caracalla. Signed and dated *No.* 32. *Francis Towne delt.,* 1781. Pen and water-colour, 12¾ × 18¾ in.

(7) The Baths of Caracalla. Signed and dated *No.* 33. *Francis Towne delt.,* 1781. (*Drawn on the spot Jan.,* 1781.) Pen and water-colour, 12¾ × 18¾ in.

(8) The old Wall of Rome at the Back of the Villa Medici. Signed and dated *F. Towne delt.,* 1781. *No.* 34. (*Drawn on the spot.*) Pen and water-colour, 12⅝ × 18¾ in.

(9) The Baths of Caracalla. Signed and dated *No.* 35. *F. Towne delt., Jan.,* 1781. (*Drawn on the spot.*) Pen and water-colour, 12¾ × 19¾ in.

(10) Baths of Titus. Signed and dated *F. Towne delt.,* 1781, *No.* 37. Pen and water-colour 12⅝ × 11⅜ in.

(11) (*a*) Road and Villa near the Arco Oscuro. Signed and dated *F. Towne delt., Rome, May* 7, 1781, *No.* 38. (*From* 11 *till* 1 *o'clock.*) Pen and water-colour, 9 × 12¾ in.

(*b*) Frascati Hill. Signed and dated *F. Towne delt. Rome* 1781. Pen and water-colour, 8⅛ × 10⅝ in.

(12) View from the Palatine Hill, looking towards the Pyramid of Caius Sestius. Signed and dated *F. Towne delt.,* 1781. *No.* 40. Pen and water-colour, 12¾ × 18¾ in.

(13) St. Peter's at Sunset, from above the Arco Oscuro. Signed and dated *F. Towne, delt.,* 1781. (*Drawn on the spot.*) Pen and water-colour, 12⅝ × 18⅜ in.

(14) S. Maria Nuova, with the Temple of the Sun and Moon, from the Colosseum. Signed and dated *F. Towne No.* 42, 1781. Pen and water-colour, 12½ × 12⅞ in.

(15) The Tarpeian Rock. Signed and dated *F. Towne delt., Rome, No.* 43, 1781. Pen and water-colour, 16 × 18⅝ in.

(16) The Temple of Concord. Signed and dated *No.* 44, *Rome, F. Towne delt.* (*Drawn on the spot.*) Pen and water-colour, 12⅝ × 19 in.

(17) The Temple of Vesta. Signed and dated *F. Towne delt., Rome, June* 27, 1781. *No.* 45. Pen and water-colour, 15¼ × 12½ in.

(18) Temple of Minerva at Sunset. Signed and dated *No.* 46, *F. Towne delt.,* 1781. (*Drawn on the spot.*) Pen and water-colour, 12½ × 14¾ in.

(19) Ponte Molle. Signed and dated *No.* 47, *Rome, Ponte Molle,* 1781. *F. Towne delt.* (*Drawn on the spot.*) Pen and water-colour, 12¾ × 18¾ in.

(20) Temple of Romulus. Signed and dated *No.* 48, *F. Towne delt.,* 1781. *Rome.* Pen and water-colour, 13⅞ × 12¾ in.

(21) In the Villa Barberini. A distant statue seen through trees in evening light. Signed and dated *F. Towne delt.,* 1781. *No.* 52. (*Drawn on the spot.*) Pen and water-colour, 10⅝ × 14⅝ in.

(22) In the Villa Barberini. Statue of an ox on a pedestal under trees, with evening light from the r. Signed and dated *No.* 53. *F. Towne delt.,* 1781. Pen and water-colour, 14 × 10½ in.

(23) The Banks of the Tiber. A wooden temporary bridge over a hollow in the foreground. Signed *No.* 54, *Rome F. Towne delt.* (*Drawn on the spot.*) Pen and water-colour, 17⅞ × 12½ in.

(24) Monte Porzio from the Villa Mondragone, Frascati. With morning light coming over the Tivoli Mountains in the distance. (1781. *Drawn and tinted on the spot.*) Pen and water-colour, 15¼ × 19⅝ in.

3. Album containing drawings of places in Italy.

(1) On the Descent from Capo di Monet, Naples. Signed and dated *No.* 7. *F. Towne delt.,* 1781. Inscribed on the back *Naples. No.* 7. *Coming down from*

Capa de Monta [sic] *drawn on the spot by Francis Towne, March, No.* 7, 1781. Pen and water-colour, 12¾ × 18½ in.

(2) NEAR NAPLES. View on the side of a valley looking towards a hill, with a distant glimpse of the Bay; peasants under trees in l. foreground. Signed and dated *F. Towne delt.*, 1781. *No.* 11. Inscribed on the back, *No.* 11. *Naples. Drawn on the spot by Francis Towne, March* 1781. Pen and water-colour, 12⅝ × 18½ in.

(3) DOMASO, ON THE LAKE OF COMO. Signed and dated *No.* 11. *Francis Towne delt.*, 1781. Inscribed on the back *No.* 11. *A view of Domaso, on the Lake of Como; the evening sunset from the right hand. Francis Towne delt., August* 27, 1781. Pen and water-colour, 11½ × 18½ in.

(4) THE LAKE OF NEMI. Inscribed *No.* 64 *Lake of Nemi. Francis Towne delt.*, 1781; and on the back *No.* 64 *Italy. Lake of Nemi. Francis Towne delt.*, 1781. *Mounted June* 28. Pen and water-colour tint (nearly monochrome), 15½ × 20 in.

(5) IN THE BAY OF NAPLES. Signed. *No.* 19 *Francis Towne delt.* Inscribed on the back *No.* 19 *Bay of Naples Francis Towne delt.*, 1781. Pen and water-colour, 10 × 18½ in.

(6) TIVOLI, FROM BELOW THE FALLS. Signed and dated No. 22 *F. Towne delt.*, 1781. Inscribed on the back *Italy No.* 22 *Tivoli. F. Towne delt., May* 15, 1781, *from* 3 *o'clock till* 6. Pen and water-colour, 19⅞ × 15⅜ in.

(7) THE SIBYL'S TEMPLE AT TIVOLI, FROM BELOW. Signed and dated *Francis Towne delt.*, 1781. Inscribed on the back *Italy No.* 13 *The Sybils Temple at Tivoli. Francis Towne delt.*, 1781. Pen and water-colour, 19⅝ × 15¼ in.

(8) VILLA OF MAECENAS AT TIVOLI FROM BELOW THE FALLS. Inscribed *Tivoli, Villa of Mecenes No.* 24 *Francis Towne delt.*; and on the back *Italy No.* 24 *Villa of Maecenas at Tivoli. Francis Towne delt.*, 1781. Pen and water-colour, 19¾ × 15⅛ in.

(9) VIEW OF TIVOLI, FROM THE NEIGHBOURING HILLS. Signed and dated *No.* 31. *Francis Towne delt.*, 1781. Inscribed on the back *Italy No.* 31. *A view of Tivoli drawn on the spot, May* 1781. *Francis Towne.* Pen and water-colour, 15¼ × 19¾ in.

(10) ARCH OF SEPTIMUS SEVERUS. Signed and dated *No.* 49. *F. Towne, July* 18, 1781. Inscribed on the back *Rome No.* 49 *Arcus Septimii Severi. Francis Towne.* Pen and water-colour, 12¾ × 28⅜ in.

(11) THE LAKE OF ALBANO. Signed and dated *No.* 7. *Francis Towne delt., July* 12, 1781. Inscribed on the back *Italy, No.* 7. *Lake of Albano; morning light from the left hand. Taken July* 12, 1781 *Francis Towne.* Pen and water-colour, 12⅝ × 25⅝ in.

(12) GROTTO OF POSILIPPO, NAPLES. Signed and dated *No.* 2. *F. Towne delt.*, 1781. Inscribed on the back *Naples, No.* 2. *Grotto of Posilipio drawn by Francis Towne*, 1781. Pen and water-colour, 12¾ × 18½ in.

(13) ROCCA DEL PAPA, FROM A ROAD BELOW THE TOWN. Signed and dated *F. Towne* 1781. Inscribed on the back *Italy, No.* 52. *A view of Rocca del Papa with part*

127

of the Convent, the outline drawn on the spot. 1781. *Francis Towne.* Pen and water-colour, 15¼ × 19⅞ in.

(14) L'Ariccia. Woods with a town above. Inscribed *Larice July* 11, 1781. *Francis Towne delt.:* and on the back *Italy Laricea July* 11, 1781. *Morning sun breaking over the Church & Buildings. Francis Towne delt.; A copy of this painted on canvas for James Curtis, Esqre* 1784. Pen and water-colour, 12¾ × 18½ in.

(15) The Roman Forum. Signed and dated *F. Towne delt., Rome* 1781. *No.* 51. Pen and water-colour, 12¾ × 23⅜ in.

(16) At Tivoli, above the Falls. Signed and dated *F. Towne delt.,* 1781. Inscribed on the back *Italy No.* 37. *At Tivoli above the Fall of the Anio, drawn by Francis Towne on the spot* 1781. Pen and water-colour, 11⅞ × 19½ in.

(17) The Falls of Terni, from below. Signed and dated *F. Towne delt.* 1799. Inscribed on the back *The Cascade of Terney, Italy, drawn on the spot by Francis Towne,* 1781. Pen and water-colour, 33 × 20¾ in.
All bequeathed by the artist, August, 1816.

A View looking towards Canon Teign, going from Chudleigh, by the Banks of the Riverside, 1785. Presented by E. H. W. Meyerstein.

VICTORIA AND ALBERT MUSEUM

Convent of S. Eufebio, near Naples.
Commonly known as the Convent of S. Efremo. 12½ × 18½ in. Signed and dated 1781.

Rydal Water
Taken at the Going off of a Storm, 6¹³⁄₁₆ × 9⁵⁄₁₆ in. Signed and dated 1786. Apparently a leaf from the sketch book used by Towne during a tour of the Lake District with Mr James White and Mr Merivale.

The Source of the Arveiron: Mont Blanc in the Background
16¾ × 12¼ in. Signed and dated 1781.

Part of Ambleside at the Head of the Lake of Windermere
Morning Effect. 6³⁄₁₆ × 9⅜ in. Signed and dated 1786.

View of Porlock and Porlock Bay, Somersetshire
Pen and wash 11½ × 19 in. Dated on the reverse *4th October* 1785. Harrod Collection.

FITZWILLIAM MUSEUM, CAMBRIDGE

A Hilly Landscape
Oil on canvas 15⅜ × 20⅜ in. Signed and dated *F. Towne, Pinxt.* 1780.

A Sketchbook
Pencil, pen and water-colour 6⁵⁄₁₆ × 9¼ in. Signed and dated *Francis Towne, August* 24, 1809. Containing 30 water-colours (chiefly views in Devon and Cornwall).

LOUGH RIGG, AMBLESIDE

Pencil, pen and water-colour $6\frac{1}{8} \times 9\frac{5}{16}$ in. Signed and dated *No. 5 F. Towne*, 1786. Inscribed by the artist, on the reverse in ink, *No. 5 Loff Rigg near Ambleside Westmoreland drawn on the spot by Francis Towne 1786 morning light from the right hand.*

RAVEN CRAG WITH PART OF THIRLMERE

Pencil, pen and water-colour $6\frac{1}{8} \times 9\frac{1}{4}$ in. Signed and dated *No. 31 F. Towne delt.* 1786. Inscribed by the artist, on the reverse, in ink *Light from the left hand 12 o'clock No. 31. Raven Crag with part of Thirlmere Lake in the Vale of St. John in Cumberland. Drawn by Francis Towne August 17th, 1786 London Leicester Square 1791* (dates partly erased).

A WOODED LANDSCAPE

Pencil, pen and grey wash $13\frac{1}{2} \times 9\frac{5}{8}$ in. Inscribed, by the artist, on the reverse, in ink, *No. 1. A Scene at Indinowle (?) August the 26th, 1783 Morning light from the left hand from 12 till 1 o'clock Francis Towne.*
Coll. Miss Judith Merivale, Oxford.

A WOODED LANDSCAPE

Pencil, pen and grey wash $13\frac{9}{16} \times 9\frac{9}{16}$ in. Inscribed by the artist, on the reverse, in ink, *No. 2 Indinowle (?) August the 26th, 1783 Morning light from the left hand from 12 till 1 o'clock Francis Towne*
Coll. Miss Judith Merivale, Oxford.

A WOODLAND LANDSCAPE

Pencil, pen and grey wash $13\frac{9}{16} \times 9\frac{9}{16}$ in. Inscribed by the artist, on the reverse, in ink, *No. 3. Indinowle (?) August the 26th, 1783 Light from the left hand from 1 o'clock till 2 Francis Towne*
Coll. Miss Judith Merivale, Oxford.

A VIEW AT NAPLES

Pencil, pen and grey-brown and light-blue washes; slightly faded $12\frac{9}{16} \times 18\frac{1}{2}$ in.; sheet folded in centre; watermark Coat of arms with Fleur de Lis, crowned. Inscribed by the artist, on the reverse in ink, *No. 1 taken at Naples Distance mont Lactarius of the antients (?) the Bay of Naples St Martini and Castle St. Elmo Naples March 17th, 1781. Francis Towne*
Coll. Miss Judith Merivale, Oxford; P. Moore Turner.

HEAD OF THE LAKE OF GENEVA, LOOKING TOWARDS MONTREUX AND THE CHATEAU DE CHILLON

Pencil, pen and grey wash $9\frac{7}{8} \times 26\frac{3}{4}$ in.; two sheets joined at centre; pasted down. Said to be dated on the reverse *Sept. 13th, 1781.*
Bequeathed by R. E. Balfour, *June, 1945.*

VIEW OF LAUSANNE

Pencil, pen and water-colour $9\frac{9}{16} \times 35\frac{5}{8}$ in.; three sheets joined together. Signed and dated *F. Towne delt. No. 11.* Inscribed on the reverse, in ink, by the artist *No. 11 A View taken above the Town of Lausanne looking over the Lakes of Geneva towards mount Jura with*

the Town of Morges and St. Prex, by Francis Towne Septr. 10th, 1781. Evening sun coming over mount Jura.

A VIEW OF MACHYNLLETH, NORTH WALES

Pencil and water-colour $8\frac{7}{16}$ × 11 in. Inscribed in ink, *No.* 10 *F. Towne delt., June 28, 1777*; inscribed verso in ink *No.* 10 *A View of Machynlleth North Wales drawn by Francis Towne*
Coll. L. S. Robinson; Miss Judith Merivale.

A VIEW IN PEAMORE PARK, NEAR EXETER

Pen and water-colour $10\frac{15}{16}$ × 17 in. Inscribed on the reverse, in ink, *A View in Peamore Park near Exeter drawn on the Spot by Francis Towne London.*
From the Merivale Family.

ASHMOLEAN MUSEUM, OXFORD

THE CASCADE AT RYDAL HALL

Pen and water-colour $9\frac{1}{4}$ × $6\frac{1}{8}$ in. Inscribed on the reverse, in ink *A View of The Cascade at Rydal-hall the seat of Sir Michael le Fleming seen through the window of the summer-house. Drawn on the Spot by Francis Towne. London.*

THE SOURCE OF THE RHINE

Pen and grey washes $10\frac{11}{16}$ × 18 in. Inscribed on the reverse, in ink *Bas Rhin— Sun on the left hand No. 21. August the 30th 1781.*

CASCADE AT AMBLESIDE. Signed and dated 1786.

Pen and water-colour $14\frac{7}{8}$ × $10\frac{7}{16}$ in. Inscribed on the reverse, in ink *A View from the Cascade in the Groves at Ambleside the Head of the Lake of Windermere drawn on the Spot by Francis Towne August 10th, 1786. N.B. the paper this is drawn on I bought myself from Rome.*

WORCESTER COLLEGE FROM WALTON STREET

Water-colours over pencil 7 × $10\frac{5}{8}$ in. Inscribed on the reverse, in ink *No.* 1. *Worcester College, Oxford from 1 o'clock till 3. August 25—1813. Francis Towne delt.*

CHRIST CHURCH FROM MERTON FIELD

Water-colours over pencil $6\frac{7}{8}$ × $10\frac{1}{4}$ in. Inscribed on the reverse, in ink *No.* 2. *Christ Church, Oxford, August 25. 1813. Francis Towne delt 2 o'clock.*

ORIEL LANE LOOKING NORTH

Water-colours over pencil $10\frac{5}{16}$ × $6\frac{15}{16}$ in. Inscribed on the reverse, in ink *No.* 4, *at Oxford, St. Mary's and Ratcliff Library from 9 to 2 past 10 in the Morning. August 25— 1813. Francis Towne delt.*

PARKS ROAD LOOKING SOUTH

Water-colours over pencil $6\frac{7}{8}$ × $12\frac{1}{2}$ in. (Sheet added to on the left). Inscribed on the reverse, in ink *No.* 3 *The School Ratcliff Library and entrance into Trinity College Gardens. August 25th. 1813. Francis Towne delt.*

NEAR MANTUROGG, NORTH WALES

Pen and water-colour 11 × 8½ in. Inscribed in ink *F. Towne delt* (erasure). *No.* 20. Inscribed on the reverse of the old mount, in ink, *North Wales No.* 20 *a view near Manturogg drawn on the spot by Francis Towne.* It probably dates from 1777.
Coll. Merivale; Mrs. Solly; Agnes and Norman Lupton.

THE BATHS OF CARACALLA

Pen with grey wash 18⅝ × 12½ in. Inscribed on the reverse in brown ink, *Rome No.* 36 *Baths of Caracalla light from the right hand* 1781 *Francis Towne.*
Coll. Merivale; Agnes and Norman Lupton.

ROCCA DEL PAPA

Pen and water-colour 9¾ × 15¼ in. Inscribed on the reverse in ink *A view of Rocca del Papa Francis Towne* 1781.
Coll. Sir Michael Sadler who presented it to Leeds, 1936.

LAKE COMO

Pen with grey wash 6⅛ × 8¼ in. Inscribed on the reverse in ink *Lake of Como Light from the left hand August* 27*th,* 1781 *No.* 28 *Francis Towne.*
Coll. Merivale; Agnes and Norman Lupton.

THE HEAD OF LAKE GENEVA

Pen with grey and blue wash 10½ × 15 in. Inscribed on the reverse in ink, *Head of the Lake of Geneva Taken at Vevay No.* 2 *Septr.* 11*n,* 1781 *Francis Towne.*
Coll. Merivale; Agnes and Norman Lupton.

PANTEN BRUCK

Pen with brown wash; 18¾ × 11¼ in. Inscribed on the reverse, in ink, *Panten-Bruck Morning light from the right Hand No.* 29 *Sept.* 3*d.,* 1781 *Francis Towne.*
Coll. Merivale; Agnes and Norman Lupton.

CROIDON HILL

Pen with grey wash 9⅝ × 12⅛ in. Inscribed on the reverse, in ink, *No.* 1 *Bickham Nr Wythycombe & Bryndon Hill to the right in the distance, Croidon Hill Sun in the middle Teambarscombe* 9 *o'clock Octr.* 1*st,* 1785 *Near Honicote Somersetshire F. Towne.*
Coll. Merivale; Agnes and Norman Lupton.

THE VALE OF ST. JOHN

Pen and water-colour 6¼ × 13⅜ in. Inscribed in ink *F. Towne. delt.* 1786. Inscribed on the reverse of the old mount, in ink, *No.* 36 5 *o'clock in the afternoon light from the left hand, A View taken in the Vale of St. John looking towards Keswick in Cumberland August* 17, 1786 *by Francis Towne.*
Coll. Merivale; Mrs. Solly; Agnes and Norman Lupton.

DERWENTWATER

Pen and water-colour $8\frac{3}{8} \times 26\frac{3}{8}$ in. Inscribed in ink *Keswick Lake, F. Towne delt.* 1786. Inscribed on the reverse of the old mount, in ink, *A View of Keswick Lake & Skiddaw, Cumberland, drawn by Francis Towne* 1786.
Coll. Merivale; Agnes and Norman Lupton.

DERWENTWATER

Pen and water-colour $8\frac{1}{8} \times 13$ in. Inscribed in ink *F. Towne delt* 1786. Inscribed on the reverse of the old mount, in ink, *Morning sun from the left hand, A View of Keswick Lake looking towards the head, drawn on the spot by Francis Towne.*
Coll. Merivale; Agnes and Norman Lupton.

LAKE WINDERMERE

Pen and water-colour $3\frac{3}{4} \times 6\frac{1}{8}$ in. Inscribed in ink, *No.* 15, 1786 *F. Towne delt.* Inscribed on the reverse of the old mount, in ink, *No.* 15, *Westmorland, on the Side of the Lake of Windermere near the Turnpike, Francis Towne delt, August* 16*th,* 1786.
Coll. Merivale; Agnes and Norman Lupton.

ULLSWATER

Pen and water-colour $5\frac{3}{8} \times 6\frac{1}{8}$ in. Inscribed in ink, *No.* 37, *F. Towne delt.* 1786. Inscribed on the reverse of the old mount, in ink: *No.* 37 *On the Lake of Ullswater going down to it from Gobarrow Park drawn on the spot by Francis Towne* 1786.
Coll. Merivale; Miss Buckingham; Mrs. Solly; Agnes and Norman Lupton.

PEAMORE PARK

Water-colour $5\frac{7}{8} \times 7\frac{1}{4}$ in. Inscribed in ink *F. Towne delt.* 1787. Inscribed on the reverse of the old mount, *No.* 16, *A View taken of the upper grounds of Peamore Park Looking towards Rocbere, Francis Towne,* 1787.
Coll. Merivale; Agnes and Norman Lupton.

VIEW FROM RYDAL PARK

Pen and water-colour $15 \times 10\frac{1}{2}$ in. Inscribed on the reverse, in black lead *From Rydal Hall Park, Light from the right hand after noon.*
Coll. Merivale; Agnes and Norman Lupton.

TREES

Pen and water-colour $14\frac{3}{8} \times 8\frac{3}{4}$ in. Inscribed in ink *F. Towne, delt.* 1800.
Coll. Merivale; Mrs. Solly; Agnes and Norman Lupton.

CLOVELLY

Pen and water-colour 7×20 in. *Verso:* Rocky Landscape. Black-lead. Inscribed on the reverse in black lead in a later hand, *Clovelly Septr.* 10*th,* 1813.
Coll. Sir Michael Sadler who presented it to Leeds through the N.A.C.F., 1931.

LANDSCAPE

Pen with grey and blue wash $10\frac{3}{8} \times 15$ in. Inscribed on the reverse, in ink, *No.* 2, *Francis Towne.*
Coll. Merivale; Agnes and Norman Lupton.

A WHARFE

Pen with grey and green washes $14\frac{5}{8} \times 8\frac{3}{4}$ in.
Coll. Merivale; Agnes and Norman Lupton.

With the exception of Rocca del Papa and Clovelly, this fine collection of Townes and many other important water-colours were bequeathed to Leeds by Agnes and Norman Lupton in 1953.

ROYAL ALBERT MEMORIAL MUSEUM AND ART GALLERY, EXETER

AT TIVOLI

Pen and wash, $9\frac{1}{2} \times 7$ in. Signed and dated 21st May, 1781 and on the reverse *No. 35, Tivoli, May 21, 1781.*

ROCKY VALLEY

Pen and wash, $11\frac{1}{4} \times 18\frac{3}{4}$ in. Colour notes on the reverse.

DENBIGH CASTLE, N. WALES

Water-colour $8\frac{1}{2} \times 11$ in. Signed and dated, 1777. On the reverse *A View of Denbigh Castle, North Wales, 1777. Drawn on the spot by Francis Towne. No. 36.*
Coll. Merivale.

OKEHAMPTON CASTLE

Water-colour $9\frac{1}{2} \times 13\frac{3}{4}$ in. Signed and dated 1794. On the reverse *Oakhampton Castle in the County of Devon. Drawn by Francis Towne, 1794.*
Coll. Merivale.

COWLEY PLACE

Water-colour $7\frac{3}{4} \times 11$ in. Inscribed on mount in Towne's hand, *View of the Seat of Wm. Jackson Esq., at Cowley Place, near Exeter.*

EXETER FROM EXWICK

Water-colour $8\frac{1}{2} \times 15\frac{1}{2}$ in. Signed and dated 1787. On the reverse *No. 1. A View of Exeter taken between Exwick and Cowley Bridge on the hill looking towards Exeter, with the river on your left-hand. This is the original outline that the large picture was painted from that was in the Exhibition of 1773. Francis Towne 1787. Society of Artists 1773.* (See below)
Coll. Merivale.

EXETER FROM EXWICK

Canvas $45\frac{1}{2} \times 63\frac{1}{2}$ in. Signed and dated.
This is the 'large picture' mentioned in the inscription on the drawing above. Given by Towne to James White. Descended to John White Abbott who gave it to the Devon & Exeter Institution in 1826. Purchased by the Royal Albert Memorial Museum, 1961. First exhibited 1773 at Society of Artists.

VIEW FROM MT. PALATINE, ROME

Water-colour $12\frac{3}{4} \times 18\frac{3}{4}$ in. Signed and dated 1785. On the reverse *No. 3. An Evening View, from Mount Palatine looking towards Mount Aventine. Drawn by Francis Towne 1785.* Ex Snow collection, probably given by Towne.

133

ROME, THE TIBER

Water-colour 12½ × 17½ in. Signed and dated 1786. On the reverse *No. 7. Rome. A View on the banks of the Tyber near Ponte Molle. Drawn on the spot by Francis Towne 1786.* Ex Snow collection, probably given by Towne.

STREET IN ROME

Oil on panel 18 × 25¾ in. Signed and dated 1800. The drawing for this picture is in the British Museum, number 3b, No. 6, inscribed *F. Towne delt. Rome Octr 31st 1780 No. 5.* Ex Coll. T. Andrew, and ?ex Coll. Merivale or given by Towne to an Andrew ancestor.

AT TIVOLI (IN THE ALBAN HILLS)

Oil on panel 18 × 25¾ in. Signed and dated 1800. Ex Coll. T. Andrew, and ?ex Coll. Merivale or given by Towne to an Andrew ancestor.

CITY OF BIRMINGHAM ART GALLERY

AMBLESIDE

Pen and water-colour 6⅛ × 18⅞ in. On two sheets of a sketch book. Signed and dated *F. Towne delt. 1786* (partly erased).

THE LAKE OF BALA, NORTH WALES

Pen and water-colour 11¾ × 24 in. On four pieces of paper gummed together. Signed and dated *No. 7, F. Towne delt. 1777.* Inscribed on the reverse by the artist *No. 7. The Lake of Bala, North Wales, drawn on the spot by Francis Towne, June 27th, 1777. Mounted October 21st, 1801*—and *A copy of this, Sr. Thomas Ackland, Bart., ordered Dec. 28, 1785.*

CHEPSTOW CASTLE

Pen and water-colour 11⅝ × 18¾ in. Signed and dated *F. Towne, delt. 1777, No. 48.* Inscribed on the reverse by the artist *A View of Chepstow Castle in Monmouthshire, drawn on the spot by Francis Towne, 1777,* an earlier (?) date scratched out and 1777 written over.

A VIEW IN LUDLOW CASTLE

Pen and water-colour 11¾ × 19 in. Signed and dated *F. Towne, delt. 1777, No. 45.* Inscribed on the reverse by the artist *A View in the Castle at Ludlow, drawn by Francis Towne, 1777, No. 45.* An earlier (?) date scratched out, and 1777 written over.

VIEW AT THE HEAD OF THE LAKE OF WINDERMERE

Pen and water-colour 6⅛ × 18½ in. On two sheets of a sketchbook. Signed and dated *F. Towne, delt. No. 14, 1786.* Inscribed on the reverse by the artist, *No. 14. A view taken near the Turnpike coming from Low Wood to Ambleside, at the head of the Lake of Windermere, in Westmorland. Drawn on the spot by Francis Towne, August 12th, 1786.* Also a list of names of the hills, etc., indicated by letters: *A, Rydal peak; B, Rydal Cragg; C, Rydal head; B, Lower Greaves and A, Higher Greaves, in Rydal Park; C, Rydal Lower peak or cragg; D, Rydal higher peak; E, Great Ridge; F, Red Crease. Leicester Square, 1791.*

134

GRASMERE, FROM THE RYDAL ROAD

Pen and water-colour, $8\frac{1}{4} \times 13\frac{1}{4}$ in. Dated 1786. Inscribed on the reverse (not by the artist), *Grasmere from the Rydal Road*.

VIEW OF A MOUNTAIN NEAR ABERDDWLA

Pen and water-colour, $8\frac{5}{8} \times 10\frac{7}{8}$ in. Inscribed on the reverse by the artist, *No. 9 View of Mountain near Aberddwla, June 27th, 1777, drawn on the spot by Francis Towne.*

NEAR NAPLES

Pen and water-colour $12\frac{3}{4} \times 9\frac{1}{4}$ in. Inscribed on the reverse by the artist *No. 10. Naples, March 24, 1781, Francis Towne.*

CASCADE AT TIVOLI

Water-colour $21\frac{1}{4} \times 30\frac{1}{4}$ in. Inscribed by the artist *Cascade, Tivoli, F. Towne, delt., No. 21, 1781* and on the reverse *Cascade at Tivoli. No. 21. Francis Towne.*

NEAR GLASIS, SWITZERLAND : EVENING

Pen and Indian-ink wash $11 \times 18\frac{1}{8}$ in. Inscribed on the reverse by the artist *No. 24. Near Glasis, light from the right hand in the evening.* Also, in pencil, *In the canton of Glasiss near the town of Glasis, evening, light from the right hand. Septr. 1st, 1781.*

PONT ABERGLASLLYN

Pen and Indian-ink wash $10\frac{5}{8} \times 16\frac{7}{8}$ in. Inscribed on the reverse by the artist, *1777, July 9th. No. 21. Pont Aberglasllyn, drawn on the spot by Francis Towne.*

IVY BRIDGE, DEVON

Pen and water-colour $9 \times 13\frac{5}{8}$ in. Signed and dated *F. Towne, delt. 1784.* Inscribed *View of Ivy Bridge in the County of Devon, drawn from the spot by Francis Towne.*

RIVER SCENE WITH MOUNTAINS

Pen and water-colour $10\frac{1}{2} \times 14\frac{3}{4}$ in. (*c.* 1786).
Coll.: Merivale.

NEAR ROCCA DEL PAPA

Pen and water-colour $15\frac{1}{4} \times 10$ in. Inscribed *The wood of chestnut trees, Francis Towne, 1780 or 1. No. 48*

PEAMORE PARK, EXETER

$17\frac{1}{4} \times 18\frac{5}{8}$ in. Signed and dated 1776. Inscribed on the reverse *A view of the arch in Peamore Park, looking towards the house, drawn on the spot August 17th, 1775, by Francis Towne, No. 3.*

PLYMOUTH. CITY MUSEUM AND ART GALLERY

PLYMOUTH FROM BELOW THE HOE, 1815

Water-colour $5\frac{1}{2} \times 9$ in.

PLYMOUTH SOUND, 1815

Water-colour (on two pieces of paper joined) $5\frac{1}{2} \times 18$ in. Inscribed on the reverse covered by mount *No. 15 From the Flagstaff in the Citadel Sladden* [*sic*] *Height on the left Ram* [*sic*] *Head on the Right Mount Batten in the middle distance. Breakwater from 11 to 1 o'clock, Sept. 5th, 1815, Francis Towne.*

LUDLOW CASTLE

Pen, with washes of colour $6\frac{1}{4} \times 7\frac{3}{4}$ in. Inscribed *F. Towne delt*, 1777, and on the reverse in a contemporary hand, *The ruins of the great room in Ludlow Castle, Shropshire were* [*sic*] *Milton's Comus was performed drawn on the spot by Francis Towne.*

WHITWORTH ART GALLERY, MANCHESTER

THE CONVENT OF ST. EFREMO, NEAR NAPLES

Water-colour $12\frac{1}{2} \times 19$ in. Similar to version in the V. & A. Signed *Francis Towne, delt.* 1783.

A VIEW OF AMBLESIDE, LAKE WINDERMERE

Water-colour $6\frac{1}{8} \times 13\frac{3}{4}$ in. Signed *No. 1 F. Towne delt.* 1786.

THE BAY OF NAPLES

Water-colour $15\frac{1}{2} \times 34\frac{1}{2}$ in. Signed *F. Towne delt* 1785.

PEAMORE PARK, NEAR EXETER

Water-colour $14\frac{1}{2} \times 10\frac{1}{2}$ in. Inscribed by the artist on the reverse, *A Study after nature in Peamore Park, Exeter, drawn on the spot by Francis Towne.*

RUINED ARCHES

Sepia monochrome $14 \times 20\frac{1}{4}$ in.

LANDSCAPE AFTER PAINTING BY CLAUDE

Sepia $8\frac{7}{16} \times 10\frac{1}{2}$ in. Inscribed by the artist, on the reverse, *From memory of a Claude which Lady Ashburnham has.*

CITY OF SHEFFIELD ART GALLERIES

WENLOCK NUNNERY

Pen and water-colour $8\frac{1}{2} \times 11$ in. Signed *F. Towne, 1777 No. 5.*

THE BOWDER STONE

Pen and water-colour $8\frac{3}{4} \times 13\frac{3}{8}$ in. Unsigned.

TEMPLE OF VENUS, BAY OF NAPLES

Pen and water-colour $12 \times 18\frac{1}{4}$ in. Unsigned.

136

NEAR MOLLES, CANTON OF GLARIS
Pen and water-colour 10½ × 15⅛ in. Unsigned.

TREES IN DEVON
Pen and water-colour 7⅞ × 6¼ in.

NATIONAL MUSEUM OF WALES, CARDIFF

VALLE CRUCIS ABBEY
Water-colour 11¾ × 19 in. Signed and inscribed *Abbey Valle Crucis Monacklog Francis Towne delt. No.* 51. Inscribed on the back, in ink, *A Copy of this was done for Sir Thomas Dyke Acland Bart. North Wales, A View of Abbey Valle Crucis Monacklog, Denbighshire drawn on the spot by Francis Towne,* and in pencil, 18 *July,* 1777.

NEAR TAN Y BWLCH
Sepia, 11 × 17¼ in. Inscribed on the back *The Vale of Tan y Bwlch, No.* 50, *July the 7th. Drawn on the spot by Francis Towne.*
Presented 1936 by Sir Leonard Twiston Davies.

MUSEUM AND ART GALLERY, NEWPORT, MON.

BACK OF HOUSES BY THE WATER
Water-colour 8 × 8½ in. Unsigned.

BRISTOL. CITY ART GALLERY

AMBLESIDE
Pen and water-colour 6⅛ × 9¼ in. Signed and dated, *Francis Towne, delt.,* 1786, *No.* 22. Inscribed on the reverse *No.* 22 *Evening Light from the right hand* 7 *o'clock Ambleside. Taken behind the Inn head of the lake of Windermere, drawn on the spot by Francis Towne August* 14*th,* 1786 *London, Leicester Square, July* (illegible).

LAING ART GALLERY AND MUSEUM, NEWCASTLE-UPON-TYNE

BRIDGE AND WATERFALL NEAR LLYN CWELLYN
11 × 17 in. Signed *F. Towne delt.* 1777

LANDSCAPE WITH WATERFALL
8½ × 11½ in. Signed *F. Towne delt.* 1789. Pencil note on mount, under drawing *Francis Towne* 1789 *Died* 1816 *aet* 76. *Bought of Hogarth* 1878 11.7 *w.* × 8.6 in. (*nearly*) *Cat.* Stamped monogram in circle on back of drawing J P = John Percy, M.D., F.R.S., born 1817.

CITY OF LEICESTER MUSEUM AND ART GALLERY

VIEW FROM TESSA AURUNCA
Pen and water-colour $15\frac{3}{8} \times 24\frac{3}{4}$ in. Signed and dated *Francis Towne delt.* 1784.

THE VALLEY OF THE TEIGN
Oil $31\frac{3}{4} \times 45$ in. Signed and dated *F. Towne pinxt*, 1780.

CECIL HIGGINS ART GALLERY, BEDFORD

THE COLOSSEUM FROM THE CAELIAN HILL WITH THE ARCH OF CONSTANTINE ON LEFT
Water-colour $12\frac{1}{4} \times 18\frac{3}{8}$ in. Signed and dated 1799.
Coll. Champernowne; Mrs. K. J. Paull.

LADY LEVER ART GALLERY, PORT SUNLIGHT

FROM THE HEATHFIELDS SEAT, LYMPSTONE
Water-colour $4\frac{1}{2} \times 14$ in.

WILLIAMSON ART GALLERY, BIRKENHEAD

PANTEN-BRUCK 1781
Wash drawing $11\frac{1}{4} \times 18\frac{1}{2}$ in. Unsigned.

TOWNELEY HALL ART GALLERY, BURNLEY

RYDAL WATER
Water-colour 10×15 in.

COOPER ART GALLERY, BARNSLEY

TIVERTON
Pen and water-colour, 6×8 in.
Coll.: Sir Michael Sadler.

NATIONAL GALLERY OF SCOTLAND, EDINBURGH

LANDSCAPE NEAR NAPLES WITH VESUVIUS IN THE BACKGROUND
Pen and water-colour $12\frac{1}{4} \times 18$ in. Unsigned.

MER DE GLACE, CHAMOUNIX

Water-colour 23½ × 34¾ in. Signed and dated *F. Towne* 179 (3 or 8).
Coll. Lord Clifford. The Sixth Lord Clifford probably obtained it direct from the
artist as he was a patron with whom Towne stayed.
[See below, Mrs. Michael Roberts' collection].

HERBERT POWELL COLLECTION

AMBLESIDE

Water-colour 6½ × 18½ in. Signed and dated *F. Towne*, 1786.

HENRY E. HUNTINGTON LIBRARY AND ART GALLERY, SAN MARINO, CALIFORNIA

THE DONKEY

7¾ × 5 in. Inscribed by the artist, on the reverse *This sketched near Exminster, Devon-
shire, Francis Towne.*

NEW FORDLAND

7¼ × 4¼ in. Inscribed by the artist, on the reverse *From 5 minutes after 11 to ¼ of
12 o'clock, light from the right hand. Fordland, August 19, 1815. Light from the left hand.*

PEAMORE PARK

16¾ × 10½ in. Inscribed on the reverse *A View Going up from the Lake in Peamore Park,
Sept. 26th, 1775.*

ON THE RHINE

8¼ × 6 in. Inscribed on the reverse *On the Rhine, No. 59, light from the right hand.*

ENGLISH LANDSCAPE WITH RUINS (Powderham)

13¾ × 10½ in.

VIEW OVER MT. SPLÜGEN

23 × 19¾ in. Signed and dated twice (1784, 1785) on the drawing. Titled and dated
1785 in the artist's handwriting on the reverse.

LAKE WINDERMERE

18½ × 6 in. Signed and dated 1786, and numbered 27. Inscribed by the artist, on
the reverse *A View of Windermere, Westmorland—August the 16th, 1786, drawn by Francis
Towne. Light from the right hand, 4 o'clock in the afternoon. No. 27.*

All from the Gilbert Davis collection.

MUSEUM OF ART, TOLEDO, OHIO

IN HYDE PARK

Water-colour 17¾ × 14½ in. Signed and dated *F. Towne delt.* 1797. Inscribed on the
reverse *This Drawing taken in Hyde Park June 19th, 1797, on the spot by Francis Towne,
No. 14 New Bond Street, London.*

TOWNE'S WORKS IN PRIVATE COLLECTIONS

The Rt. Hon. the Earl of Halifax

POWDERHAM CASTLE
Oil 54 × 79 in. Signed and dated *F. Towne*, 1777.

The Rt. Hon. the Earl of Devon

POWDERHAM CASTLE
Water-colour 18 × 24 in. Inscribed on the reverse *This View of Powderham to be painted in a size four times as large each way by order of Ld. Courtenay, Oct. 22nd, 1774.*

The Rt. Hon. the Lord Clifford of Chudleigh

UGBROOKE PARK
Ten drawings and water-colours—a very important series, the earliest dated 1773, the latest 1787.

MER DE GLACE, 1793, $23\frac{1}{2}$ × 35 in.

VIEW OF A TREE AT STAPLE HILL FARM, 1773, $19\frac{1}{2}$ × $17\frac{3}{4}$ in.

The Rt. Hon. the Lord Clwyd

VIEW IN THE ALPS
Monochrome drawing.

Sir William Worsley, Bart.

LUDLOW CASTLE
$22\frac{1}{2}$ × $11\frac{1}{2}$ in. Signed, 1777. No. 46.
Coll. Solly.

THE GROVE, WERRINGTON PARK
$18\frac{1}{2}$ × $13\frac{1}{2}$ in. Signed, 1799. No. 79.
Coll. Merivale.

VILLA DRAGONA GARDENS, FRASCATI
Pen and wash 15 × $9\frac{1}{2}$ in. Inscribed on the reverse. Signed 1781.
Coll. Merivale: Sadler.

BLASTED PINE IN THE VILLA DRAGONA GARDENS.
Pen and wash $12\frac{1}{2}$ × $8\frac{1}{2}$ in. Inscribed on the reverse. Signed, 1781.
Coll. Merivale.

ROME

Going out from the Porta Pia and looking towards the Sabine Mountains.
Water-colour 11 × 8½ in. Inscribed on the reverse. Signed 1781.
Coll. Merivale.

THE FIR TREE

Water-colour 15 × 10 in., c. 1800.
Coll. Merivale.

THE AVENUE

Water-colour 15 × 9 in., c. 1800.
Coll. Merivale.

SHAUGH. A HILLY LANDSCAPE

Water-colour 9 × 5½ in.
Coll. Loveband; Butterwick.

FROM WEST INDIA DOCKS.

Water-colour 7 × 4½ in. Inscribed on the reverse. Signed, 1813.
Coll. Merivale.

LOOKING TOWARDS GREENWICH HOSPITAL

7 × 4½ in. Signed, 1813.
Coll. Merivale.

WINDSOR CASTLE, 1. St. George's Chapel. Trees, houses, figures, cattle.

Size 7 × 4½ in.
Coll. Merivale.

WINDSOR CASTLE, 2. With trees, cattle and figures.

Size 7 × 4½ in.
Coll. Merivale.

MADONNA SAN GIACOMO

Pen, tinted 18 × 11 in. Signed 1781. Inscribed *Evening sun from the right, August 28th,*
1781.
Coll. Merivale.

DEVON LANDSCAPE

7½ × 4½ in.
Coll. Merivale.

VIEW TAKEN NEAR EXWELL

25½ × 18 in. Signed, 1779.

I

TOWN OF LUGANO

Pen and wash 10 × 18 in. Signed 1781. Inscribed on the reverse *Evening light from the left-hand breaking on the buildings, August 24th, 1781, No. 4.*
Coll. Merivale.

LAKE OF LUGANO

Pen and wash 10 × 18 in. Signed 1781. Inscribed *Taken from Mendris, September 1st, 1781, No. 3.*
Coll. Merivale; Horne; Marsh.

LAKE OF WALLENSTADT

Pen and wash 8½ × 6 in. Signed 1781. Inscribed *Taken from Wesen, September 1st. 1781, No. 47. Morning light from the right-hand.*
Coll. Merivale.

TIVOLI

Pen and wash 19½ × 14½ in. Signed 1781. Inscribed *May 15th, 1781, 5 o'clock in the morning, light coming from the sun rising over the mountains. Strong on vapour, thin against the olive trees. Second mountain darker than the olive trees and trunks of the trees darker against the mountain. The herbage in the cave in its light a deep bright green. Olive trees greyer.*
Coll. Merivale.

VEVEY

Pen sketch 12½ × 9 in. Signed 1781. Inscribed *September 20th, 1781, la Tour de Pie. All the tops of the buildings darker than the lake.*
Coll. Merivale.

TIVOLI WATERFALL AND TOWN

25 × 18 in. Signed 1780.
Coll. Turner (for whom it was painted by Towne).

WATERFALL BETWEEN CHIAVENNI AND MT. SPLÜGEN

22½ × 19½ in. Signed 1781. Inscribed *No. 14, Morning light from the right-hand. August 29th, 1781.*
Coll. Merivale; Sadler; Routh.

CASTELLO MADAMO

12½ × 9½ in. Signed 1781.
Coll. Merivale; Routh.

KESWICK LAKE

8½ × 12½ in. Signed 1805.
Coll. Merivale; Routh

THE CLAUDIAN AQUADUCT AT ROME

18½ × 12½ in. Signed 1785. Inscribed *Looking towards Mount Palatine—drawn by Francis Towne, 1785, No. 4.*

Coll. Snow.

(This water-colour and the next were drawn on the spot (in 1781) and finished off later on.)

TEMPLE OF VENUS. Looking towards the Island of Nisida.

19½ × 13½ in. Signed 1786.
Coll. Snow.

VAUXHALL STAIRS FROM MILLBANK

7 × 8 in. Signed 1797. Inscribed *By Francis Towne, July 5th, 1797, No. 114, New Bond Street.*

THE CHESTNUT WOOD

Pen and wash 12½ × 8½ in. Signed 1781. Inscribed *Near Rocca del Papa. Wood of chestnut trees. No. 44.*
Coll. Sadler; D. Eccles; Routh; Horton.

WINDERMERE 1.

9 × 6 in. Signed 1786. Inscribed *A view taken at Low Wood looking across the head of the lake of Windermere in Westmoreland to the mountains at the head of Coniston lake. Taken after the sun was down on the right-hand side. Drawn on the spot by Francis Towne, August 16th, 1786. No. 29.*
Coll. Paull (K. J. Paull of Chichester—by descent from Champernowne collection. Mr. Champernowne of Dartington Hall, Devonshire, was a contemporary of Towne's and one of his few private patrons).

WINDERMERE 2.

9½ × 6 in. Signed 1786. Inscribed *A view taken at Low Wood looking across the head of the lake of Windermere in Westmoreland to the Langdale Pike. Taken after the sun was down. Drawn on the spot by Francis Towne, August 16th, 1786, No. 28.*
Coll. Paull.

VILLA ADRIANA 1.

6¼ × 8½ in. Signed 1781. Inscribed *Light coming from the left-hand side. No. 41. May 22nd 1781.*
Coll. Selwyn Image.

VILLA ADRIANA 2.

8½ × 6¼ in. Signed 1781. Inscribed *Afternoon light from the left-hand. No. 42. May 22nd, 1781.*
Coll. Selwyn Image.

VILLA ADRIANA 3.

6½ × 8½ in. Signed 1781. Inscribed *Light from the left-hand side. Afternoon. No. 40. May 20th, 1781. Francis Towne.*

MER DE GLACE, CHAMONIX

23½ × 35½ in. Signed, 1778.
Coll. Clifford.

LAKE MAGGIORI

6¼ × 8¼ in. Signed 1781. Inscribed *A view over the lake—light from the left—sunset over the mountains. No. 20, Aug. 25th,* 1781.

LAKE MAGGIORI

6¼ × 8¼ in. Signed 1781. Inscribed *Light coming from the left. No.* 21. *Aug. 25th,* 1781.

THE BRIDGE AT BARTON PLACE

Sept. 18, 1804. 9¾ x 6¾ in.

UGBROOKE PARK

July 17, 1805.

Sir John Heathcoat Amory, Bart.

ITALIAN WOODLAND SCENE

Monochrome, with some blue sky, 20 × 12 in

CADER IDRIS

Two water-colours, one of the mountain in the distance and rolling ground in various shades of green and brown leading up to it, and the other a lane and big pine trees with Cader Idris behind. The first 14 × 12 in. and the second 14 × 8 in.

Sir Bruce Ingram, M.C.

IN OKELY PARK, July, 1777

Pen and wash 11¼ × 18⅝ in. Inscribed on the reverse.

THE BAY OF NAPLES

Pen and wash 8¾ × 12⅜ in. Signed and inscribed on the reverse.

RHAIDDA DU, NORTH WALES

Pen and water-colour 12½ × 19⅞ in. Signed and inscribed on the reverse.

D. L. T. Oppé, Esq. and Miss Armide Oppé

LE REVE, 1781

Water-colour 6⅛ × 8¼ in. Signed on the drawing *No.* 33 *F. Towne delt.* 1781, and inscribed on the reverse *Le Revé [sic] at the head of the Lake of Como, drawn by Francis Towne, August the 28th,* 1781, *No.* 33.

TOP OF THE SPLÜGEN PASS. 1.

Water-colour 6 × 8¼ in. Inscribed on the reverse with the title.

THE TOP OF THE SPLÜGEN PASS. 2.

Water-colour, 5¾ × 8¼ in.

VIEW GOING OVER MOUNT SPLÜGEN, 1784

Water-colour 18⅝ × 22¼ in. Inscribed by the artist on the reverse *A View going from the head of the Lake Como over mount Splugen. Taken on the spot by Francis Towne.* Coll. Lord Redesdale. *This and a near duplicate once belonging to Gilbert Davis, derive from Towne's No. 14, dated 29th August, 1784 in the collection of Sir William Worsley.*

LAKE OF COMO, 1781

Water-colour 6⅛ × 8¼ in. Signed and dated *F. Towne, No. 32 delt.*, 1781, and inscribed on the reverse *Lake of Como. Drawn from Nature.*

TOWARD THE HEAD OF THE LAKE OF COMO. AUG. 27, 1781.

Water-colour 6⅛ × 8¼ in. Signed and dated *No. 30, F. Towne, delt.* 1781, and inscribed on the reverse with the title as given, and *Drawn by Francis Towne August the 27th, 1781, No. 30. Light from the Left Hand.* Coll. Champernowne.

IN THE CAMPAGNA LOOKING TOWARDS THE SABINE MOUNTAINS

Water-colour 9¼ × 18⅝ in. Inscribed on the reverse *The Campagna near Rome looking towards the Sabine mountains.* The sketch on the spot from which this finished drawing was made is at the British Museum (L.b.3 (a)), inscribed *Two miles from Rome going out at the Porta Pia October 26, 1780, No. 5.*

LAGO MAGGIORE, 1781, No. 8

Monochrome 11¾ × 18¾ in. Inscribed on the reverse *Monte Simplen: a View of Lago Maggiore, taken from Lavano with Isola Bella on the left hand and Isola Madre on the Right the two Borromean Islands. No. 8, Aug. 28, 1781.* There is also a note about the river Tessin and *This drawing to be done for Miss Basing* 10 *guineas* and *Court Borromeo.* Coll. Merivale.

WATERFALL NEAR AMBLESIDE, 1786

Pen and water-colour 14⅞ × 10¾ in. Coll. Merivale. One of three varying treatments of the subject.

LA CHAPÉRIEUX, SEPTEMBER 16, 1781

Pen and water-colour 6⅛ × 8¼ in. Inscribed by the artist on the reverse *La Chapérieux, L'aigle, Le Bouchard, Sept. 16th, 1781, No. 51.* Coll. Merivale (B.P. 86).

MONTE CAVO, 1781, 1.

Water-colour with body-colour in the sky. 9½ × 15 in. Signed, *No. 53. Francis Towne del.* 1781, and inscribed on the reverse *Italy No. 53. The Spot where Hannibal is said to have lookt at Rome from. Drawn by Francis Towne on the spot* 1781.

MONTE CAVO, 1781, 2.

Water-colour with body-colour in the sky 9⅝ × 15⅛ in. Signed and inscribed as the last but numbered 54.

THE SOURCE OF THE ARVEYRON, 1781

Pen, partly erased with knife, and water-colour on two sheets of paper $12\frac{1}{4} \times 8\frac{3}{8}$ in. Signed and dated *F. Towne*, 1781, and inscribed on the reverse *No. 52. A View of the Source of the Arviron drawn by Francis Towne, Sept.* 1781.

BISONE, AUGUST 24, 1781

Water-colour $6 \times 8\frac{1}{4}$ in. Inscribed by the artist, on the reverse *Bisone on the Lake of Lugano, August 24th No. 18. Drawn by Francis Towne.*

ROCKS AND TREES AT TIVOLI, 1781

Pen and water-colour $15\frac{1}{2} \times 19\frac{3}{4}$ in. Signed and dated *At Tivoli, Francis Towne, May 1st, 1781, deln.*, and inscribed by the artist on the back *Italy. A Study on the Spot at Tivoli. Francis Towne del 1781 May, Leicester Sqre. Mounted June, 1811.*

IN A WOOD NEAR ALBANO, 1781

Pen and grey wash $12\frac{5}{8} \times 17\frac{5}{8}$ in. Signed and dated *F. Towne delt.* 1781 and inscribed at the back *Taken in a Wood near Albano* 1781.

THE WALLS OF ROME

Water-colour $6 \times 8\frac{3}{8}$ in. Though clearly of the same series as the other small drawings of Italy and Switzerland and mounted by Towne himself, this drawing is unusual in being without an inscription either on back or front.

WALLENSTADT, SEPT. 4, 1781

Pen and grey wash $6 \times 8\frac{1}{4}$ in. Inscribed by the artist on the back *Lake of Wallenstadt Sept. 4th*, 1781. *No. 47 Francis Towne. Light from the left hand.*
Coll. Merivale.

NAPLES AND CAPRI, 1798

Water-colour $15\frac{3}{4} \times 24$ in.
The drawing from nature on which this is based, was in the Merivale collection (Towne's No. 13). It has a note on the back *Feb. 6, 1788, John Short Esq. ordered this subject. N.B. 8 gns.*
Coll. John Lane.

LAKE OF LUGANO, AUGUST 24, 1781

Pen and grey wash $6\frac{1}{8} \times 8\frac{1}{4}$ in. Inscribed by the artist on the back *On the Lake of Lugano, August 24th*, 1781, *No. 16, Francis Towne. Light from the left hand.*
Coll. Merivale.

NEAR FLORENCE

Water-colour $6 \times 8\frac{1}{4}$ in. Numbered 8 and inscribed on back: *The mountains about miles on the road from Florence to Bologna.*

A VIEW BY MOONLIGHT IN THE BUNHAY AT EXETER, 1792

Pen and water-colour $6\frac{1}{4} \times 7\frac{3}{4}$ in. Signed and dated *F. Towne delt* 1792, the title as given inscribed on the reverse.

146

A VIEW AT PINES THE SEAT OF SIR STAFFORD NORTHCOTE, BART, NEAR EXETER

Fine pen, brown monochrome washes $10\frac{3}{4} \times 14\frac{5}{8}$ in. Signed and dated *F. Towne* 1778 and inscribed with the title as given on the back of the old mount. Sir Stafford Northcote, 1762–1851, of Pynes near Upton Pyne, Devon, was the ancestor of the present Earl of Iddesleigh.

NEPTUNE'S GROTTO AT TIVOLI

Pen and water-colour $14\frac{1}{2} \times 19$ in. Inscribed *Tivoli, Neptune's Grotto, Francis Towne,* 1781, *No.* 39.
Coll. Merivale.

GOING UP MOUNT SPLÜGEN

On two pieces of paper $8\frac{3}{8} \times 9\frac{1}{8}$ in. Signed *Francis Towne delt* 1781, and inscribed on the back of the mount with the title as given, and *drawn on the spot.*

LANDSCAPE COMPOSITION

Pen $5\frac{3}{8} \times 8\frac{1}{4}$ in. Inscribed on the mount by F. Abbott, *Francis Towne* 1780, *My Godfather.*

IN KENSINGTON GARDENS

Water-colour $7\frac{1}{2} \times 11$ in. Inscribed by the artist (partly pasted over) . . . *delt Kensington Gardens . . . & New Bond Street,* and numbered *No.* 44 at the top, c.1797.

A WATERFALL NEAR LIDFORD

$10\frac{7}{8} \times 8$ in. Title inscribed on the back.

NEAR MOUNT SPLÜGEN

Pen and grey wash $8\frac{1}{4} \times 6\frac{1}{8}$ in. Inscribed on the reverse in ink *Near Mount Splugen Aug.* 29, 1781, *No.* 37 *Francis Towne. Light from the left hand.*

LANDSCAPE No. I

Water-colour $5\frac{3}{8} \times 7\frac{3}{8}$ in. Signed on the reverse *Francis Towne delt. Savile House, No. 5 Leicester Square, London,* and numbered 1. Possibly the first drawing made in Switzerland in 1780 on the small paper used by the artist during this tour. A copy by his pupil Miss Maingy, 1790, is in a volume in the collection of Iolo A. Williams, Esq.

NETLEY ABBEY

Water-colour on two pieces of paper $14 \times 19\frac{1}{4}$ in. Signed *F. Towne delt. No.* 4, 1809, or some other date ? 1798. On the back of the mount inscribed by the artist *No. 4 Netley Abbey drawn on the spot Francis Towne.* A drawing of this subject was at Barton Place (No. 215) as *No. 2 Netley Abbey* 1798, *8th September.* Towne exhibited at the Royal Academy in 1809, No. 330 "View of Netley Abbey".

NEAR MOUNT SPLÜGEN

Pen and wash $8\frac{1}{4} \times 6\frac{1}{8}$ in. Inscribed on the reverse *Near Mount Splugen Aug.* 29, 1781, *No.* 37 *Francis Towne. Light from the left hand.*

THE SOURCE OF THE RHINE
Pen and grey wash 6⅛ × 8¼ in. Inscribed on the reverse *Near the source of the Rhine Alps descending from Mount Splugen.*

LAKE OF URI
6 × 8¼ in. Inscribed on the reverse *Lake Uri, Sept. 5th, 1781. Morning light from the left hand. No. 48 Francis Towne.*

PEAMORE PARK
Pen and grey wash, 10⅜ × 16½ in.

LANDSCAPE WITH ROCKS
Water-colour, oval. 8 × 11½ in.

GREAT FULFORD
Pen and wash. Signed and dated August 8, 1776.

LAKE OF COMO
Water-colour 6⅛ × 8¼ in. Signed, and inscribed *No. 26 F. Towne 1781,* and on the back of the mount *No. 26 Lake of Como drawn from nature by Francis Towne* (erasure) *Light from the right hand.*

LIDFORD WATERFALL
Grey monochrome wash 12⅛ × 8⅛ in. Signed *Frs. Towne del 1780.* Back of mount inscribed *A view of the Waterfall at Lidford in the county of Devon drawn on the spot by Francis Towne.*

UGBROOKE 10⅝ × 16½ in.

TORR ABBEY 12½ × 16⅜ in.

Tom Girtin, Esq.

MODERN BRIDGE AT NARNI
Water-colour 8 × 11½ in. *Signed F. Towne delt.* 1795. After J. Smith (see *Views in Italy,* Plate XIX).
Coll. Merivale.

ON THE LAKE OF COMO
Water-colour 6 × 8¼ in. Inscribed on back in contemporary hand.

Miss A. H. Scott-Elliot

THE SALMON LEAP, FROM PONT ABERGLASLLYN
Pen and water-colour 11 × 8¼ in. Signed and dated *No. 23 F. Towne delt.* 1777, and

148

inscribed on the reverse *a view of the Salmon Leap from Pont Aberglasllyn. Drawn on the Spot by Francis Towne 1777* (over erasure), *Leicester Sqre, London. Morning light from the right hand*
Coll. the Merivale family.

Iolo A. Williams, Esq.

ALPINE LANDSCAPE WITH TORRENT

Pen and water-colour, $11\frac{3}{8} \times 18\frac{1}{2}$ in. Signature *F. Towne* is partly erased but still just legible.

A VIEW IN THE APENNINES

Pen and water-colour $6\frac{1}{8} \times 8\frac{3}{8}$ in. Signed on the front *F. Towne delt. 1781 No. 6.* Inscribed on the reverse *No. 6. Light from the right hand. A View looking towards the Apennines. Drawn August 11th 1781 by Francis Towne.*

ON THE SIDE OF THE RHINE NEAR THE SOURCE

Pen with brown, grey-blue and grey-mauve washes $10\frac{1}{4} \times 11\frac{1}{8}$ in. *On the side of the Rhine near the source, light coming from the right hand side, Aug. 29th* (Copy of the inscription on the drawing as typed on the Squire Gallery's label on the back of the frame).
Mr. Williams writes: "I believe this is only the visible section of a larger drawing, the remainder (unfinished) being folded back in the frame, though possibly it has been cut off. At any rate I once saw it (before it was mine) with an unfinished section visible".

LAKE OF GENEVA, 1781

Pen and grey wash with blue in the sky, $10\frac{1}{8} \times 14\frac{1}{2}$ in. Signed on the reverse and numbered 2.
Coll. Merivale.

Mr. and Mrs. W. W. Spooner

RYDDCRAG AND LUFFRIGG

Water-colour $18\frac{1}{4} \times 5\frac{7}{8}$ in. Inscribed on the reverse 1786.
Coll. Merivale; H. B. Milling.

NORTH HILL, NR. PORLOCK, SOMERSET

Water-colour $8\frac{1}{4} \times 6\frac{1}{4}$ in.
Coll. Merivale

PISTYLL Y RHAIADR

Water-colour $14\frac{3}{4} \times 11\frac{3}{4}$ in.
The stream divides the County of Denbighshire and Montgomery, the Lordships of Powis and Chirk, the perpendicular height from which it falls 240 ft. Drawn 1777—signed, inscribed and dated—*No. 6.*
Coll. Merivale; Miss Helen Barlow.

Landscape with Horseman
Pen and water-colour $6\frac{1}{2} \times 9$ in. Signed on reverse.

In the Valley of the Grisons
Water-colour 18×11 in. Inscribed *In the Valley of the Grisons looking on Jusis in the morning, drawn by Francis Towne on the spot* and on the reverse *No.* 19 Dated 1781.

Dr. John Malins

Berry Castle (Berry Pomeroy).

Bickley Vale and Shaugh Church

View of Plymouth

Frascati
Monochrome, 1781

View of a Hermitage, Rocca del Papa
Monochrome, 1781

The Wrekin from the Road from Wenlock to Shrewsbury
Monochrome

Antony Gibbs, Esq.

A View looking up the River Exe, Devonshire
Oil, 66×46 in. Inscribed on the reverse with title and *Painted by Francis Towne in the year* 1811, *No.* 31 *Devonshire Street, Portland Place. No.* 1.

Miss J. M. Loveband

The New Forest
$19\frac{1}{2} \times 7$ in. Signed and dated 1798. On verso: *No.* 1. *A South View in the New Forest, Francis Towne, del., Sep.* 11, 1798 *from* 10 *till* 3 *o'clock.*

Two Swiss Scenes
4×6 in. Unsigned.

W. A. Brandt, Esq.

Park in Devon with Peasants driving a Donkey
Water-colour $10\frac{3}{4} \times 7\frac{3}{4}$ in. Signed and dated *Fr. Towne, June 14th,* 1800.

Woody Landscape
Pen and wash, $13 \times 16\frac{1}{4}$ in. Signed *F. Towne delt.*
Coll. Guy D. Harvey-Samuel, Esq.

150

John White Abbott, Esq.

TIVOLI

Sepia, 15 x 9¾ in. Inscribed *No.* 17 *at Tivoli drawn on the spot.* 1781.

KESWICK, LOOKING TOWARDS SKIDDAW

Water-colour 4 x 6⅜ in. Inscribed *No.* 30 *at Keswick looking towards Skiddaw.* 1786.

Leonard Duke, Esq., C.B.E.

NEAR DOLGELLY

Pen and Indian wash, slightly tinted with water-colour, 10⅜ × 18¼ in. Inscribed by the artist, on the reverse *A View near Dolgelley with part of Cader Idris. June 30th, 1777. No.* 11. *Drawn on the spot by Francis Towne.*
Coll. Merivale.

Mrs. Michael Roberts

MER DE GLACE, CHAMOUNIX

10 × 26 in. Signed and dated *September,* 1781. Inscribed by the artist, on the reverse *No.* 9, *Glaciere taken from Montanvert looking towards Mount Blanc, September* 16, 1781 12 *o'clock. Light from the right hand.*
Coll. Merivale. This is the original sketch for the drawing in the Aberdeen Art Gallery.

T. R. C. Blofeld, Esq.

ON THE BANKS OF THE RIVER DEE NEAR LLANGOLLEN, NORTH WALES

10¼ × 11¾ in. Inscribed *No.* 43, *F. Towne, delt. July* 17, 1777, and on the reverse, with title, signature and number.
Coll. Merivale; Mrs. E. M. Young.

W. G. S. Dyer, Esq.

DUNSFORD BRIDGE ON THE TEIGN

Water-colour. Inscribed with the title, signed and dated *Francis Towne,* 1785.

Mrs. D. V. Garstin (U.S.A.)

FALLS OF THE MOTHVAYE

Water-colour, 12⅝ × 17 in. Inscribed *No.* 14, signed and dated 1777, and on the reverse *A View of the Cataract of the Mothvaye, in Merionethshire, North Wales. Drawn on the spot by Francis Towne,* 1777. *London, Leicester Square.*

View of Bath, c.1777.

Reprod. *Country Life*, 24 Feb., 1940, p. xvi.

Many oil paintings.

Note: Exhibitions in which Francis Towne's works have been featured are Agnew's, 1949; Festival of Britain, 1951, Royal Albert Memorial Museum and Art Gallery, Exeter; Sheffield, 1952; Leeds, 1954; Geneva-Zürich, 1955/6; Royal Academy Diploma Gallery, 1959.

BIBLIOGRAPHY

Laurence Binyon, *English Water-Colours*, London, A. & C. Black, 1933

Laurence Binyon, *Landscape in English Art and Poetry*, London, Cobden-Sanderson, 1931

Joseph Farington, r.a. (Edited by James Greig), *The Farington Diary*, 8 volumes, London, Hutchinson & Co., 1922–28

Winslow Jones, *Francis Towne, Landscape Painter*, Exeter, 1890.

Edward H. A. Koch, *Leaves from the Diary of a Literary Amateur : John Herman Merivale, 1819–1844*, Hampstead, The Priory Press, 1911

Henri Lemaitre, *Le Paysage Anglais a l'Aquarelle 1760-1851*, Paris, Bordas, 1955

Anna W. Merivale, *Family Memorials*, Exeter, 1884

Charles Merivale (Edited by Judith Anne Merivale), *Autobiography and Letters of Charles Merivale, Dean of Ely*, Oxford, 1898

The Walpole Society Annual Volumes, notably Vols. VIII, XIII, XXII and XXIII

William T. Whitley, *Art in England, 1800–1820*, Cambridge, University Press, 1928

William T. Whitley, *Artists and Their Friends in England, 1700–1799*, 2 volumes, London & Boston, The Medici Society, 1928

William T. Whitley, *Thomas Gainsborough*, London, Smith Elder, 1915

Iolo Aneurin Williams, *Early English Watercolours and some Cognate Drawings by Artists born not later than 1785*, London, The Connoisseur, 1952

G. C. Williamson, *John Downman, A.R.A. : His Life and Works.* London, Otto (Connoisseur extra number), 1907

George C. Williamson, *Life and Works of Ozias Humphry, R.A.*, London, John Lane, 1918

George C. Williamson, *Richard Cosway, R.A., and his Wife and Pupils : Miniaturists of the Eighteenth Century*, London, George Bell & Sons, 1897

ARTICLES

Adrian Bury, *Some Roman Drawings by Francis Towne*, The Connoisseur, July 1938

Martin Hardie, *Early Artists of the British Watercolour School : Francis Towne*, The Collector, September 1930

CATALOGUES

Algernon Graves, *The British Institution 1806-1867: A Complete Dictionary of Contributors and Their Work*, London, 1908

Algernon Graves, *The Royal Academy of Arts*, London, 1905–06

Algernon Graves, *The Society of Artists of Great Britain 1760–1791 ; The Free Society of Artists 1761–1783*, London, 1907

Catalogue of Drawings by British Artists and Artists of Foreign Origin working in Great Britain preserved in the Dept. of Prints and Drawings in the British Museum, London, British Museum, 1907

Forty Drawings of Roman Scenes by British Artists (1715–1850) from Originals in the British Museum (with notes by T. Ashby), London, British Museum, 1911

Catalogue of Water Colour Paintings by British Artists and Foreigners working in Great Britain. London, Victoria & Albert Museum, revised edition, 1927

Catalogue of a Collection of Pictures . . . and Water-colour Drawings by Francis Towne, Burlington Fine Arts Club, Winter 1929–30

Early English Water Colour Drawings by Francis Towne and John White Abbott. Lent by the Royal Albert Memorial Museum, Exeter, Miss Merivale, Mrs. Prevost and Mrs. Abbott. Oxford Arts Club, Boswell House, 1931

Loan Exhibition of Water-Colours by Francis Towne, Property of A. P. Oppé, C.B. Thomas Agnew & Sons, October 1949

Festival of Britain, Royal Albert Memorial Museum, Exeter, 1951

Early English Drawings and Water-Colours from the Collection of Paul Oppé, Esq., Graves Art Gallery, Sheffield, 1952

Leeds Art Calendar, 1954

Early English Water-Colours in the Collection of Sir William Worsley at Hovingham Hall, 1957

Paul Oppé Collection, Royal Academy Diploma Gallery, 1958

Water-Colours and Drawings in the Cecil Higgins Collection, Bedford, 1959

INDEX

JOSEPH CRAWHALL

THE MAN AND THE ARTIST

By ADRIAN BURY, R.W.S.

Foreword by Sir Alfred Munnings
Past President of the Royal Academy

"At a time when the market is flooded with repetitive and often uneven books on painters who are already too well-known, it is refreshing to find one of real quality on an artist who is hardly known . . . One of the last and finest of our painters of animals and birds, Crawhall was a minor master, and that this book is finely done is a tribute no more than properly fitting."—*Manchester Guardian*

"A complete study of Joseph Crawhall was long overdue, and Adrian Bury was the right man to undertake the work. This beautifully produced book is an understanding tribute by a writer who shares the aesthetic viewpoint of the painter."
—*Apollo*

"Printing, binding and reproductions are excellent and I cannot think of anyone better equipped than Adrian Bury to assemble the facts and present them with style, dignity, understanding and sympathy. He is, of course, an experienced writer on Art and Artists; but I choose to regard and acclaim this as the best thing he has ever done. His narrative is never padded out with irrelevances and his critical comments are as direct as they are sound. The monograph should be in the library of every educational institution concerned with the teaching of Art and History . . . recommended without qualification."—Dr T. J. Honeyman, former Director of Glasgow Art Galleries, in *Scotland's Magazine*

"Adrian Bury, an able writer and a water-colourist of no small achievement himself, has embarked upon this task of bringing Crawhall's name and works to a wider public with great courage . . . Very seldom do the works of this artist come upon the market, but when they do, they usually fetch a price that places his work among the greatest of water-colourists . . . Publisher and author alike have certainly made a worthy contribution to the honour of the memory of this fine artist."
—*The Artist*

"Joseph Crawhall was a fastidious craftsman with a fine sense of design . . . Mr Bury's detailed comments are not only an aid to enjoyment but virtually offer a course of instruction in the finer points of the water-colourist's craft."—*Yorkshire Post*

"All that Mr Bury writes of the artist and his works is of close interest. He and the publishers must be congratulated most sincerely."—*Melbourne Age*

"Mr Adrian Bury, an authority on English water-colour, has made his researches and has written his appreciation with obvious pleasure and a penetrating eye . . . An incomparable pictorial record which must increase in value."—*The Studio*

Demy 4to. With many plates in collotype and colour, £5 5s od net

PUBLISHED IN A LIMITED EDITION OF 975 COPIES BY

CHARLES SKILTON LTD
PUBLISHERS AND PRINTERS